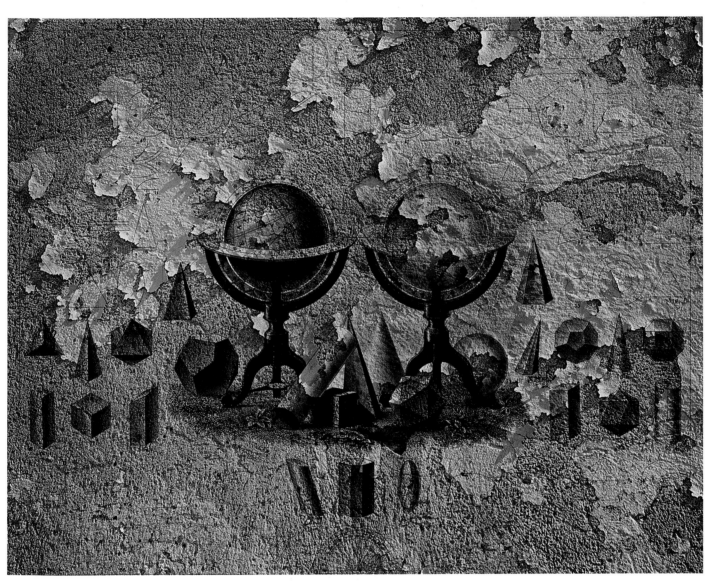

1987

J E R R Y U E L S M A N N

JERRY UELSMANN

Foreword by A. D. Coleman

University Press of Florida

Gainesville
Tallahassee
Tampa
Boca Raton
Pensacola
Orlando
Miami
Jacksonville

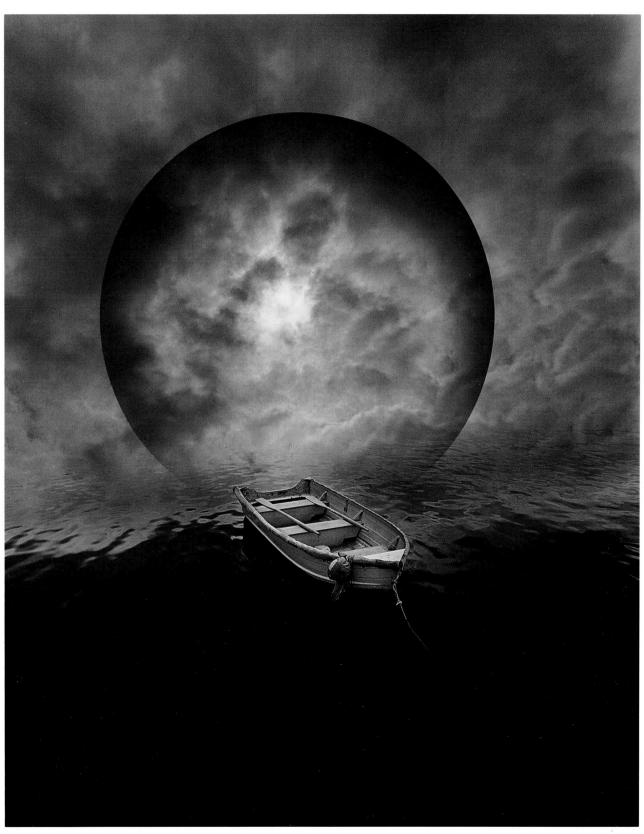

1982

To Maggie and Andrew

Foreword copyright 1992 by A. D. Coleman
Photographs copyright 1992 by Jerry N. Uelsmann
Printed in China
All Rights Reserved

06 05 04 03 02 01 10 9 8 7 6 5

Library of Congress Cataloging-in-Publication Data

Uelsmann, Jerry, 1934–
Jerry Uelsmann: photo synthesis / foreword by A. D.
Coleman.
p. cm.
ISBN 0-8130-1159-0 (cloth). — ISBN 0-8130-1160-4
(paper)
1. Photography, Artistic. 1. Title. 11. Title: Photo
synthesis.
TR654.U325 1992
779'.092—dc20 92-10515

The University Press of Florida is the scholarly
publishing agency for the State University System of
Florida, comprised of Florida A & M University,
Florida Atlantic University, Florida International
University, Florida State University, University of
Central Florida, University of Florida, University of
North Florida, University of South Florida,
University of West Florida.

University Press of Florida
15 Northwest 15th Street
Gainesville, Florida 32611
http://www.upf.com

PREFACE

The images in this book were selected from the ones that represent, in my view, the strongest work of my career thus far. I chose them largely on the basis of two criteria. The first was long-standing appeal—those that have sustained a certain vision or message or resonance over the years. Another way to say this is that such images seem to work as well today as they did when I first made them. (In the case of the more recent ones, I'll have to wait and see if they stand the test of time.) My second guiding principle was to present a record of the expression of my own changing identity over the years as an individual and as a photographer.

The photographs are not presented in chronological order. As I began to select and arrange them, the organizing principle that emerged focused on juxtapositions of facing pages—images that prompted a dialogue. These images seemed to relate to each other visually or intuitively or psychologically, sometimes involving similarity or contrast or both. As I tried out different combinations—in much the same way that I work in the darkroom when I'm manipulating various negatives—meaningful comparisons emerged. Most of these comparisons had to do with different treatments of recurring elements or themes—sometimes used many years apart.

Once these juxtapositions were determined, the ideas that have consistently motivated me seemed clearer than ever before. Although I have always resisted the impulse to categorize art, because it limits the artist and the viewer, certain subjects clearly recur in my photographs: images from nature; the integration of nature and the human figure, and of exterior and interior environments; human relationships; and a psychological preoccupation in which the symbolism is sometimes obvious and sometimes mysterious. Some of my psychologically motivated photographs seem to express the darker side of myself; others seem to embrace the Jungian notion of human consciousness. Although I have never formally studied Jung, I have always felt a particular attraction to the Jungian ideas of the expression of the collective unconscious and the transmission of creative power through the symbols and patterns of myth.

It is difficult for me to articulate the darkroom experience. It always comes back to the fact that it is important for me to create images that challenge one's sense of reality. While many people are aware of a kind of camera-charisma, few sense the possibilities of sustaining mystery and magic within the darkroom. The darkroom experience affords us the opportunity for new beginnings. Not bound by traditional darkroom technique, we can keep the visual search alive. In-process discovery can illuminate new possibilities, giving birth to images that enable us to question and expand our own vision.

BIOGRAPHY

Born in Detroit on June 11, 1934, Jerry Uelsmann received his B.F.A. degree at the Rochester Institute of Technology in 1957 and his M.S. and M.F.A. at Indiana University in 1960. He began teaching photography at the University of Florida in Gainesville in 1960 ("my first job offer"). He has been graduate research professor of art at the university since 1974.

Uelsmann received a Guggenheim Fellowship in 1967 and a National Endowment for the Arts Fellowship in 1972. He is a Fellow of the Royal Photographic Society of Great Britain, a founding member of the American Society for Photographic Education, and a trustee of the Friends of Photography.

Uelsmann's work has been exhibited in more than 100 individual shows in the United States and abroad over the past thirty years. His photographs are in the permanent collections of many museums worldwide, including the Metropolitan Museum and the Museum of Modern Art in New York, the Chicago Art Institute, the International Museum of Photography at the George Eastman House, the Victoria and Albert Museum in London, the Bibliothèque National in Paris, the National Museum of American Art in Washington, the Moderna Museet in Stockholm, the National Gallery of Canada, the National Gallery of Australia, the Museum of Fine Arts in Boston, the National Galleries of Scotland, the Center for Creative Photography at the University of Arizona, the Tokyo Metropolitan Museum of Photography, and the National Museum of Modern Art in Kyoto.

His other books are *Jerry N. Uelsmann* (Millerton, N.Y.: Aperture, 1970); John L. Ward, *The Criticism of Photography as Art: The Photographs of Jerry Uelsmann* (Gainesville: University of Florida Press, 1970); *Jerry Uelsmann: Silver Meditations* (Dobbs Ferry, N.Y.: Morgan & Morgan, 1975); *Jerry N. Uelsmann: Photography from 1975–79* (Chicago: Columbia College, 1980); *Jerry N. Uelsmann— Twenty-five Years: A Retrospective* (Boston: New York Graphic Society, 1982); and *Uelsmann: Process and Perception* (Gainesville: University Presses of Florida, 1985).

FOREWORD

A. D. Coleman

The photomontages of Jerry N. Uelsmann are as instantly recognizable as any photographic images made in the second half of the century now drawing to a close. Today they stand as germinal, the progenitors of an approach to photographic image-making so well-established and widespread that it's strange to recall (and, for a younger audience, no doubt difficult to imagine) the storm of controversy that raged around them when they first began appearing in the early 1960s.

Aside from enunciating a personal preference or practice, who nowadays would impeach as creatively illegitimate "the willingness on the part of the photographer to revisualize the final image at any point in the entire photographic process"?[1] Who would propose that photomontage was not part and parcel of the photographic tradition—that it was at best little more than an aberration, at worst a perversion of the medium? Who would assume that a photographer choosing to work in that form should feel it incumbent on himself to provide his peers and colleagues with a rationale for that decision, an *apologia pro vita sua*? After all, such images are now part of our regular diet, generically a commonplace in galleries, museums, monographs and other venues for serious photography. Courses and workshops on their production are standard in the photo-educational system. And their offspring are to be seen everywhere, from MTV to the Op-Ed pages of the *New York Times*.

When Uelsmann began working in this form of photography three decades ago, the context in which he labored was almost the polar opposite to that in which he functions today. Partly due to his consistent and determined efforts—as practitioner, as theorist, as teacher, as public lecturer, and generally as exemplar—the working definition of what constitutes the full field of ideas and strategies in contemporary photography is a far more expansive one than that which was operative when he set out on his path.

Consequently, coming to terms with his presence in the medium at this stage requires addressing not only his body of work itself but its relationship to the field of creative photography and its implications in regard to the larger media environment in which photography has operated during the period of the work's evolution.

Photomontage vs. Photocollage

As a prelude, it might be useful to speak of the object nature of these works—that is, to define the way in which they're made. This is especially true because, with increasing frequency, the term *photomontage* is being used to describe what are clearly

1. This definition of Uelsmann's process was first offered and elaborated in Jerry N. Uelsmann, "Post-Visualization," *Florida Quarterly* 1 (Summer 1967): 82–89.

works of *photocollage*.[2] Neither of these terms should be used as an umbrella to cover what are in fact two radically different forms of photographic image-making. They are far from synonymous; it's useful and, in fact, instructive to distinguish between the two.[3]

As practices, both can be traced back to the nineteenth century. They emerged shortly after William Henry Fox Talbot's invention of the negative-positive process, which brought with it the option not only of making multiple photographic prints on paper but also of interpretive intervention in the passage between exposure and print. The terms *photomontage* and *photocollage* themselves were originated early in this century by the Berlin Dadaists. Often used interchangeably by them and by those who came after, these terms have become difficult to separate: even practitioners of the same method frequently define their process differently. (For example, the great anti-Fascist polemicist John Heartfield called himself a *photomonteur*, and the playwright Bertolt Brecht went so far as to claim that Heartfield had "invented" that form; yet even Heartfield's brother and lifelong collaborator, Wieland Herzfelde, acknowledges that *photocollage* is the more apt description of his brother's work.[4])

The French word *collage* means "gluing"; the craft process is that of pasting varied materials together. *Photocollage*, then, involves the cutting up and reassembling of parts of photographic prints or reproductions of photographs. In itself, this does not necessarily require any specific photographic activity. All that is consistently photographic in such images is the origin of some of the component parts. Because many forms of such imagery can be generated without the use of a camera or a darkroom, it has attracted not only photographers but visual artists from outside the parameters of photography—Romare Bearden and Barbara Kruger are only two diverse examples from the United States. Indeed, it is the form of photographic image-making that has been most accessible to photographers and nonphotographers alike.

Some of those who work in this form (Kruger, for instance) conceive of the original collage as a matrix from which to derive photographic copy prints with a unified surface, or even as a basis for the generation of photomechanical reproductions —posters, newspaper and magazine illustrations, book covers. Others, like Bearden, conceive of the original collage as the finished work. In both these cases, as in others, the collages may also incorporate nonphotographic elements (paint, colored paper, cellophane tape, objects, texts, and so forth). Suffice it to say that photocollage—requiring as it does some version of that "contempt for materials" advocated by Man Ray[5]—is not a medium for purists.

In the visual arts, the term *montage*—French for "assembling, putting together"—was first applied to film editing. In essence, with each splice the film editor decides when to merge and how to blend two separate moments of vision, and how to rationalize their linkage. The perceptual phenomenon known as *the persistence of vision* assures that, even if briefly, the viewer's memory of moment A will be *overlaid* on moment B. Transferred from the kinetic medium of cinema to the static medium of photography, the term can have a precise meaning. Strictly speaking, *photomontage* is the superimposition of one image on another; this can be achieved in such a way that both are simultaneously present and visible—that is, they *show through each other*— or so that the added images appear integral to the depicted scene.

Accomplishing this requires photographic methods. One of these is "double" or multiple exposure, done while the negative is still in the camera; Harry Callahan and numerous others have utilized this technique. Montage processes can also be executed in the darkroom, as with multiple printing (exposing the printing paper to part or all of several negatives in succession) and combination printing, or the "sandwiching" of negatives (printing two or more superimposed negatives simultaneously). These are the techniques in which Uelsmann has specialized. In such cases, both the image components and the techniques involved are purely photographic in nature.

While the differences between photocollage and photomontage are crucial, what those image-makers who explore the two have in common is also worth pointing out. Regardless of which approach they embrace, they all alter or combine photographic imagery in ways that require a healthy irreverence for the documentary integrity of the original negative or the inviolability of the

2. For example, in several New York gallery shows by Martha Rosler in late 1992.

3. The extent to which these terms have become problematically conflated is illustrated by Cynthia Wayne's catalogue essay for the survey exhibit "Dreams, Lies, and Exaggerations: Photomontage in America" (College Park, Md.: The Art Gallery, University of Maryland at College Park, 1991). In her definition of terms for this essay, the author feels obliged to plead her case for including works other than photocollages—i.e., in-camera or darkroom-produced photomontages—under the heading of photomontage!

4. Wieland Herzfelde, "Heartfield's Photomontages and Contemporary History," in John Heartfield, *Photomontages of the Nazi Period* (New York: Universe Books, 1977), 17–18.

5. "A certain amount of contempt for the material employed to express an idea is indispensable to the purest realization of this idea." Man Ray, "The Age of Light," in *Man Ray: Photographs* (New York: East River Press, 1975), xv.

print. Yet while they may fragment or otherwise manipulate that imagery to a great extent, its photographic origin is obviously important to them. Thus, although their methods and intentions vary widely, it is apparent that they are all aware of and actively utilizing the peculiar psychological affect of the photographic image, whose facticity and temporality always refer us to its source in a specific time and place.

In the last analysis, the long-range intent of these artists is less to create an effective illusion of quotidian reality than to refer simultaneously to diverse aspects and moments of reality by combining portions of different photographic images, which encode the surface appearance of those aspects and moments. It is in the nature of photographs to particularize. But when thus fragmented, mixed, and reorganized, they can be made to generalize as well—to symbolize classes of things in addition to representing the single instance which is their subject. This is one strategy for indicating to the viewer that the appropriate territory of interpretation for such imagery is the poetic.

Photomontage and the Photographic Tradition

Though photocollage concerns itself with elements of the photographic, its patchwork end results tend to be objects that cannot be literally described as photographs. Moreover, even when rephotographed and printed on light-sensitive materials, internal evidence—the seams joining the various components, for example—generally remain apparent, undermining any illusion of integrality.[6] For those reasons, photocollage does not seriously challenge the recordative function of the photograph; as a form, it simply employs fragments of lens imagery for patently different purposes.

Photomontage, conversely, tends to be produced on photographic paper and to look (at least at first glance) like unmanipulated imagery; as Uelsmann's oeuvre demonstrates, even when the combinatorial nature of the finished work is recognized it may offer little or no indication of where one component ends and another begins. Those who employ it as an imagistic strategy demonstrably lack devotion to any realistic imperative connected to photography, though they are no less clearly aware of the omnipresence of that attitude in our cultural relation to the medium. Thus they deliberately propose a radical alternative to the naturalism that has been the stock-in-trade of photography since its inception. Photomontage provides unsettling evidence that, paradoxically, although the camera must always address something in front of the lens, some photographs portray events that never happened.

Even when (as is often the case with Uelsmann) the viewer is confronted with deceptively seamless images which at first and even second glance may be perceived as literal documents, the anti-realism of what is depicted manifests itself rapidly, if not immediately. Only someone extremely unsophisticated in relation to lens imagery could fail to realize, during the course of his or her first encounter with a body of such work, that these are not documents of any single moment of external "reality." Their purpose, patently, is not to delude the viewer into the permanent conviction that that's how things really looked. Instead, they set the viewer up for a delayed perceptual double-take. By thus contradicting the viewer's assumptions concerning the predictability and literalness of the photograph, they redirect attention to the specific image itself—the viewer is asked not to believe but rather, in a theatrical sense, to suspend disbelief. This heightens awareness of the imagery's artificiality and evokes a different set of questions in regard to its purpose.

One might argue plausibly that photomontage can be considered a form of "pure" photography, but no one would sensibly propose that it (or photocollage) falls within the tradition of realism. Regardless of approach, images in this form declare themselves to be non- and even anti-realistic. They are descriptions of inner states rather than external phenomena. (This is true even of those images whose makers' concerns are patently sociopolitical—for example, those of Heartfield and, sometimes, Barbara Morgan.) Certainly they're not "documents" in any sense of the word. They provide no plausible visual evidence; instead, they persuade us to their cause (if they do) through metaphor—metaphor reliant on the logic of dreams as much as, if not more than, on the logic of rhetoric.

Because this process inherently contradicts the "window on the world" assumptions that Western culture imposed on photography from its birth, dispute has always swirled around this practice. The process of photomontage first attracted widespread attention in the mid-nineteenth century through the directorial, literary work of Henry Peach Robinson and O. G. Rejlander, whose techniques and results were the subject of heated and even violent debate among photographers and critics. Vernacular photography—postcard imagery and portraiture in particular—popularized it. The pictorialist movement of the late nineteenth and early twentieth century embraced it; in the 1920s it became a staple of modernist practice in Europe, even entering the photographic curriculum devised

6. There are of course exceptions, such as the work of Adal Maldonado and Allen A. Dutton.

for the Bauhaus by Laszlo Moholy-Nagy, who called it "simultaneous seeing by means of transparent superimposition."[7] But modernists in this country—led by Alfred Stieglitz and Paul Strand—repudiated it, and the photo-historical establishment here, sharing their biases, virtually banished it from the scene.[8]

Yet even when photomontage has fallen into disfavor, it has refused to die. Around the middle of this century—before Uelsmann and others of his generation began exploring this constellation of photographic techniques—such North American experimenters as Morgan, Edmund Teske, Clarence John Laughlin, and Val Telberg were pursuing them.[9] However, in the post–World War II American photo scene, the "purist" approach advocated by photojournalists on the one hand and Edward Weston, Ansel Adams, and the West Coast school on the other was dominant. In one way or another, they preached what Adams called "previsualization": the full realization of the image at the moment of exposure. By their lights, any subsequent tampering with the data on the negative was anathema.[10]

Uelsmann—goaded into his inquiry by his mentor at Indiana University, the late photographer, educator, and theorist Henry Holmes Smith—set out to demonstrate that there was another way. By the middle 1960s he had produced a body of work that in his opinion proved the viability of photomontage as a contemporary image-making strategy. Issuing in 1967 a position paper that described his contrary methodology as "post-visualization,"[11] this seemingly mild-mannered midwesterner threw down his gauntlet. In the words of Peter Bunnell, this challenge—and the way in which Uelsmann has risen to its demands as a picture-maker over the years—can appropriately "be seen to have altered the language, the substance, and the direction of [the medium itself]."[12]

Uelsmann's Photomontage: Lyric Poetry in a New Language

In the late 1950s and early 1960s—during and after his graduate studies under Henry Holmes Smith—Uelsmann devoted a great deal of study, experiment, and energy to reviving the processes he found relevant to his vision. Compiling and using an image bank of negatives from which he could draw specific components, he evolved an idiosyncratically ruminant methodology, chewing and rechewing the cud of a particular symbol in image after image. In this approach to praxis, the darkroom became a locus for what a jazz musician might call improvisation on a theme; Uelsmann refers to it as "in-process discovery."

Eventually, he developed his printmaking skills to the point where he could blend any number of those components seamlessly into one final image. (Eschewing the expedient of the copy negative, which many photomonteurs employ as a labor-saving device, he continues to make each silver-gelatin print of any given image from scratch.) And he then took the step—rare in photography, though not uncommon in the other creative media—of issuing an articulate, cogent manifesto-cum-credo, explaining in broad terms what he was doing, why he was doing it, and why he continued to call himself a photographer.

Coming as it did from a tall, gangly man whose B.F.A. graduation photo in the Rochester Institute of Technology's 1957 yearbook portrayed him as clean-cut and anything but wild-eyed, that deliberate act of provocation a decade later must have seemed particularly out of left field. This is especially true given the fact that R.I.T. never was a hotbed of radical artistic experimentation; closely connected to the Eastman Kodak Corporation, it boasted a highly technical curriculum emphasizing photographic science and applied photography (and was, as has recently been revealed, already a C.I.A. front). That photographers as diverse as

7. "A New Instrument of Vision" (1932), in *Moholy-Nagy,* ed. Richard Kostelanetz (New York: Praeger, 1970), 52.

8. For an account of the effect of this purge on the appreciation of the work of the leading pictorialist photographer, writer, and teacher William Mortensen, see A. D. Coleman, "Disappearing Act," *Camera Arts* (January-February 1982): 30–38, 108.

9. Although (and, perhaps, because) there are few traces of the stylistic influence of others to be found in even his earliest work, Uelsmann has been admirably scrupulous, generous, and affectionate in paying homage to his precursors. For example, Telberg was for decades better known among filmmakers and writers (due especially to his long-term collaboration with the writer Anaïs Nin); he is only now being brought into the ranks of significant contemporary photographers. Yet I can recall hearing Uelsmann acknowledge Telberg's significance decades ago. I can also remember the delight with which, in 1974, Edmund Teske read to me a letter from Uelsmann punningly proclaiming Teske one of his "occult heroes."

10. Virtually alone among her North American peers, Barbara Morgan managed to keep a foot in both camps without any loss of credibility as a photographer of a basically purist persuasion. Though long overshadowed by her more famous (and more subject-dominated) dance photographs, her photomontages—which move curiously between the politically programmatic (*Hearst over the People,* for example) and the more ambiguously private—were exhibited and published at the time of their making, without significantly affecting her reputation. But those of her peers already mentioned who pursued this approach at greater length were either ostracized or ignored by the photo-historical establishment.

11. Uelsmann, "Post-Visualization," 82–89.

12. Peter C. Bunnell, "Introduction," in *Jerry N. Uelsmann: Silver Meditations* (Dobbs Ferry, N.Y.: Morgan & Morgan, 1975), unpaginated.

Uelsmann and Bruce Davidson evolved their own creative identities in that constricting environment testifies to the strength of their visions, and to the teaching power of such atypical faculty members as Minor White and Ralph Hattersley, who were Uelsmann's first two influences. (The third—and, according to Uelsmann, the most important—was Smith.)

Issued at that particular historical moment, "Post-Visualization" virtually guaranteed that Uelsmann would find himself in the eye of a storm for years to come; not only did it declare its author's intent to serve as a spokesperson for the approach described therein, but it implied his willingness to have his work treated as a litmus test for the theory's validity, an example of its application in practice. Surviving severe criticism and outright rejection of his initial efforts by his peers, Uelsmann persevered, finding an audience and forging a major body of work in this form over the next three decades. It's that body of work that is surveyed here, with the emphasis on the output of the past decade.

In part, the self-evident durability of Uelsmann's work can be attributed to the high standards for virtuoso performance in printing that he established and has maintained; simply put, there's no one who does this better. Consequently, even now there's little to gauge it by except itself, for it's against Uelsmann's example that the field measures itself. Yet if his results were less than resonant, the technical accomplishment, however admirable, would be hollow—especially since the imagery he's had in mind all along succeeds only when the technique remains subliminal, invisible. For unless the world according to Uelsmann strikes the viewer as an organic if improbable whole, the entire project falls apart.

And what is that world? From the beginning, Uelsmann has elaborated an oneiric cosmology: an idiosyncratic, sometimes obliquely and sometimes directly autobiographical dream-world. This microcosm partakes of the surreal, in its non- or anti-literal evocation of dreams, fantasies, visions, and hallucinations—as when the interior of the domestic environment and the exterior of the natural world become inexplicably bollixed, or figures float through the air as if levitating, or flying—as well as in the recurrent symbol of the hand, a key element in classical surrealist photography. It also is imbued with strong elements of the grotesque, in that term's traditional art-historical meaning. There are consistently grotesque motifs throughout his imagery: these include bizarre apparitions of disembodied human parts, the merging of human beings with various natural objects—rocks, trees, and the like—and the blending and intertwining of other animal, mineral, and vegetable forms. These are central themes of the grotesque in art and literature.[13] Were Uelsmann of Latin American descent, one certainly would not hesitate to use the term "magical realism" in discussing his imagery.

Yet to say this is not to encompass the work, but simply to indicate some of the threads in its complex weave. These images resist easy categorization: to label Uelsmann a surrealist, a pantheist, a mythologist, or a diarist is to disregard other, equally significant aspects of his work. The strongest visual art, virtually by definition, resists verbalization, a fact true of photography as well. Yet, as Peter Bunnell has noted in discussing the early critical and public response to Uelsmann's work, "Most people still tend to think that when photographers make pictures they must depict objects and scenes that could, in principle, also be described in words."[14] These images are indeed difficult to describe in words; I have a fond memory of trying (and failing utterly) to do so once at 4 A.M. on a radio talk show.

What seems inarguable is that, in addition to proving the validity of his approach by producing imagery that at its best is unsettling, enchanting, magical, and oddly melancholy, Uelsmann has demonstrated a remarkable consistency of vision. Though his mastery of photographic printmaking has become ever more virtuosic, there's been no dramatic change in his imagery. (Indeed, the very nature of his working process—whereby an image component such as a pea pod may be reutilized in a variety of contexts over an entire lifetime—establishes not only an inherent continuity within the oeuvre but a distinct sense of the recurrent. One could even think of some of these key elements as *revenants* in his ongoing saga.)

True, the friezes that bordered images from the '70s have disappeared, and the scapes seem generally more open and spacious. For better or worse, a certain amiable if sometimes embarrassing goofiness in image and titling seems to have slipped away. And the craft has grown ever more subtle and intricate. But otherwise the work of the '60s and the work of the '80s is very much of a piece. Certain structural configurations (interior/exterior integrations, for example) remain consistent; his involvement with several of the traditional forms of visual art (portraiture, the nude, the landscape) persists. Consequently, chronological ordering of his work tells us less about it than does a more thematic orientation.

13. For more on this, see A. D. Coleman, *The Grotesque in Photography* (New York: Ridge Press/Summit Books, 1977).
14. Bunnell, "Introduction," *Silver Meditations*.

As William Parker has demonstrated,[15] Uelsmann's work is illuminated in notable ways by a Jungian analysis of his symbology. Yet Uelsmann's imagery is not premised on Jungian thought; if it does coincide with Jungian archetypes, that results not from advance planning but from Uelsmann's openness to his own intuition and his consequent access, through it, to what Jung called the "collective unconscious." Part of the pleasure of engaging with Uelsmann's photographs, in fact, is that the dance of symbols therein never seems theory-driven, intellectualized, or otherwise forced, but emerges, unpremeditated, through play and experiment. For that reason, his persistent inclusion of the redundant, the mundane, even the downright foolish—dumb jokes (especially in his affectionate portraits) and bad puns—does not, for me at least, impeach either its credibility or its fundamental seriousness; my own reveries contain enough of the repetitive, the humdrum, and the silly that Uelsmann's use of such material seems more a way of maintaining emphasis on the personal, even private basis of the work.

Fundamentally, he's a wanderer through inward scapes, in which we're welcome to join him; yet he's hardly proposing that we treat him as a leader by substituting his dreamlands for our own. James Enyeart has referred to the results of Uelsmann's process as constituting a "spontaneous mythology,"[16] but that suggests ambitions on an epic scale—and in that regard it seems to me that, the enormous size of his oeuvre notwithstanding, Uelsmann has chosen to function as a lyric poet rather than an epic one.

At this juncture, my own sense of what he's about is that, labels aside, he's trying to annotate his mind voyages and invent the language in which to tell of them at the same time. Because he is not extensively involved with image-text relationships (even eschewing titles for the most part), treats his images as autonomous, and in exhibition form does not insist on presenting his prints in any particular order, his relation to narrative is not immediately clear. But Steven Klindt has proposed that the numerous variant versions of an image Uelsmann generates during his darkroom explorations constitute sequences. He also adds, "I was pleased to learn of another interpretation of time passage in Uelsmann's photographs when I discussed . . . Uelsmann's work with [photographer, teacher, and theorist] Richard Kirstel. . . . Kirstel feels that the sequential passage of time in Uelsmann's work is 'synchronic' within the picture. He spoke very convincingly of how, in one picture, Uelsmann can present a mysterious [chain] of events unfolding before our eyes yet contained in one image. To see these photographs as sequential—whether within a single print as Kirstel does or through groups as I do—is to read Uelsmann's work in a new way."[17]

If we take Uelsmann's purpose to be the evolution of a purely visual form suitable for his narrative, then I'd have to add that what's been said about writers—that most have one book in them, which they write over and over—holds true for Uelsmann as well. Again and again in his imagery, a lonely and often shadowy male figure (usually the photographer himself), seeking contact with the Other, searches convoluted, mysterious, multidimensional scapes pervasively animated by the Feminine; but though the protagonist often sights that Other, in the form of various women, he is unable to touch her, and comes up empty-handed time after time. At the risk of being reductive, I'd assume that this tale is autobiographically based; but I'd hasten to add that its lamentation goes far beyond the *puer aeternus*: mourning is its emotional tenor, its alienation has become elegiac, and its sense of the intangibility and transience of the human is profound. If there is an epic component to Uelsmann's work, then his proper analogue would be Homer: not he of the extroverted *Iliad*, but he who composed the *Odyssey*—he whose introspective protagonist encounters and survives the magic, terror, and mystery of the world, only to find that the home whose remembered image sustained him and drew him back can never be truly regained.

Photomontage as Media Prophecy

In our time, more than in any previous one, the degree to which visual images coexist, impinge upon, and breed with one another has been brought to public consciousness. Many factors have contributed to this awareness. One, of course, is its inevitability: whatever paucities afflict our lives, lack of imagery is not one of them. Marshall McLuhan was fond of saying, concerning cultural attention to the effects of media, "Whoever discovered water, it wasn't a fish"—his point being that we take our environment for granted. Now, it could be argued that, as human beings are no less "natural" creatures than any others, an imagistically saturated environment *is* our natural habitat at a certain stage in our evolution; it simply took us a while to develop to the point where we could generate it for ourselves. Even if that were the case, though, clearly there was some

15. William Parker, "Uelsmann's Unitary Reality," *Aperture* 13, no. 3 (1968): n.p.
16. James L. Enyeart, "Introduction," in *Jerry N. Uelsmann—Twenty-five Years: A Retrospective* (New York: New York Graphic Society, 1982), 46–50.

17. "Introduction," exhibition catalogue, *Jerry N. Uelsmann: Photographs from 1975–79* (Chicago: Chicago Center for Contemporary Photography, Columbia College, 1980), unpaginated.

transition, some metamorphosis—recent enough that some vestigial memory remains to signal us that we have undergone a noteworthy change.

The knowledge of this ongoing transformation is not exclusively privileged to visual artists, nor restricted to a widened circle that includes academics and media critics; reference to it, even animated discussion of it, takes place everywhere—daytime TV, the pages of *People* magazine. Combine this awareness with a fundamental insight we owe to psychoanalysis—that the unconscious generates endless combinations and permutations of whatever we feed to it—and it can come as no surprise that so much art in this century of mass media addresses directly the issues of received imagery and image hybridization. As Ezra Pound pointed out, "Artists are the antennae of their race." It is their job to taste the future for their culture, to see what nourishments and poisons it may hold.

That future seems inextricably bound up with the lens-based media—still photography, film, and video; these technologies generate the bulk of the imagery that has pervaded our culture. Yet a rapidly increasing proportion of that imagery resembles only tangentially what we were (until recently) accustomed to referring to as *photographs* (self-contained, slice-of-life extractions from single moments in space and time). Until relatively recently such works were misunderstood, disregarded, even despised, by the critical/historical establishment. However, the past two decades have seen a radically revisionist examination of the medium's history by critics, historians, and practitioners alike. One result has been the reconsideration and reclamation of all available techniques for the production of photographic images. Consequently, works like Uelsmann's that, twenty years ago, had to fight for the right to be considered as part of the continuum of artistic/photographic activity now seem classic examples of a tradition—indeed, a tradition that, given the increasing presence of digitized photography, is unquestionably on the verge of technological obsolescence.

Ironically, photography must take responsibility for that imminent archaism. For, by establishing on the shores of Western culture a beachhead for a form of expression and communication that was very much involved with science and technology, photography paved the way for acceptance of creative work in subsequent media with a similar involvement. And if photography makes the process of visual representation widely available, the computer makes the act of image manipulation into literal child's play. The combination of the two will inevitably transform visual communication (of which the visual arts are a subdivision), making possible not only the digital encoding of images but

the generation of virtually infinite permutations and variations thereof: not merely everyone a photographer but everyone a picture editor, a photocollagist and/or a photomonteur.

Equally important is the fact that this technology innately deemphasizes the physicality of art. The primary display format for the images is the video screen itself. These new systems thereby permit image production without object production as a necessary concomitant. It is in the nature of such systems to focus attention on the differences between the images created with them, rather than on the distinctions between the objects that embody those images. Thus they encourage a relationship to the work of art not as crafted object but as dematerialized image and idea. The terms *photomontage* and *photocollage* may no longer prove descriptively useful in that environment; perhaps something like *image hybridization* will replace them both.

Such work already exists, albeit (and I do not mean this insultingly) in still infantile and inchoate versions. By my lights, no one has yet produced a body of computer-generated imagery that can stand as a fully realized creative oeuvre. Yet there's no question that this achievement is inevitable; thus the archaization of darkroom-based photomontage as a craft can already be said to be imminent. Meanwhile, there's surely irony galore in the fact that versions of the disputes that took place over Uelsmann's early imagery within the microcosm of the photography community are now appearing in the mass media, in regard to the appearance therein of electronically generated composite images. Photomontage, it seems, has been all along a prophecy of the media environment in which lens culture would eventually find itself situated.

It appears to be Uelsmann's fate to have established photomontage as legitimate and viable within classic photographic practice, only to witness the obsolescing of that practice in its entirety by the onslaught of digitized imagery. In that sense, we can see him as a terminus: the artist who brought silver-based, darkroom-generated photomontage to its pinnacle of virtuosic expression before its replacement by electronic imaging. But we can also view him as a springboard: in building a wide international audience for his own imagery and encouraging his colleagues in their parallel experiments, he helped prepare that receptive soil in which computer-generated imagery is now taking root. (He may even have contributed to this eventuality with his didactic commitment: probably no other photomonteur in history has so diligently and devotedly passed on his or her craft expertise to so many students and colleagues, quite a few of whom have taken what they learned from him and

applied it not to the silver print but to the computer screen.)

Yet, as long as he'd be permitted to pursue his own procedures, I don't think he'd regret that transition; in fact, had the home computer been available to him when he started out, I suspect he might have bypassed silver-based photography entirely and avoided the decade of battle. This was never a man spoiling for a fight over what was or was not permissible in creative photography, merely someone whose vision carried him into one.

And that's really the point—for it's true of most who've chosen to work in this form. Notwithstanding a considerable degree of critical confusion over and even disdain for the forms called photomontage and photocollage, artists have for generations kept them alive and energized for their peers and those who have come after. By doing so, they helped to establish the present-day climate of acceptance in which the legitimacy of these forms and their offspring is no longer seriously questioned. The persistence of those pioneering workers in exploring these media, despite the lack of any clear tradition or craft system, provides undeniable evidence that these forms are essential to art in our time. The urge toward this hybridization, the dissolution of hierarchies within and distinctions between media, and the attack on the assumed inviolable realism of the photograph, have been first and foremost *creative impulses*; they originated with picture-makers.

The historiography and criticism of nineteenth- and twentieth-century image-making is only beginning to catch up with these developments. To do so effectively will require those disciplines to address directly the impact of new image-making technologies on artistic production, as well as the complex interaction between "high" art, vernacular art, mass media, and culture—and the extent to which photography is deeply implicated in all of these. That this should take place is imperative, for it is only through such inquiry that we can evolve a comprehensive critical/historical overview of the hybrid imagery of the twentieth century and the forces that impelled its production. It is from the analysis of the hand-crafted, labor-intensive montages and collages of the past hundred years that we will derive the understanding needed to address their electronically generated descendants on the brink of their first swarming. And no such study will be treated seriously that does not take the theory, the practice, the teaching, and—most importantly of all—the imagery of Jerry N. Uelsmann into account.

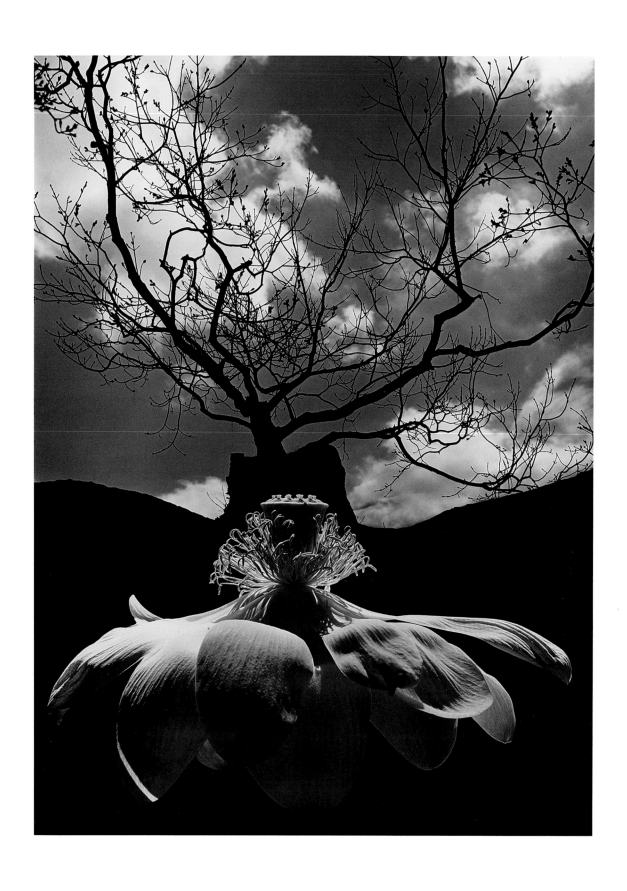

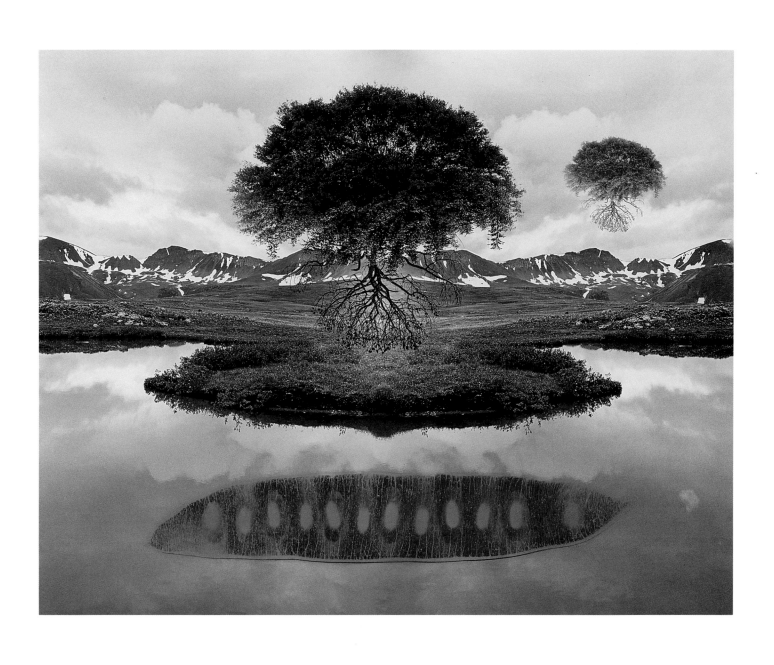

3 * 1969

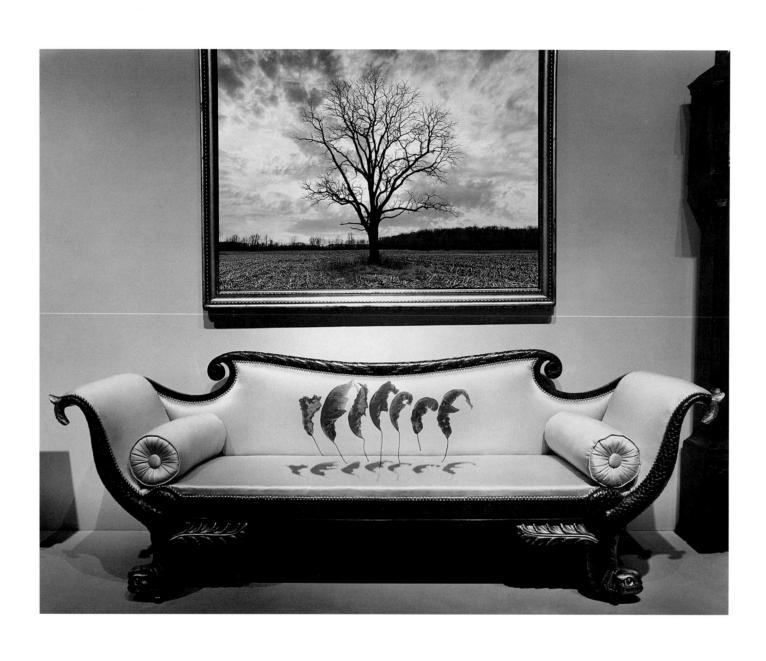

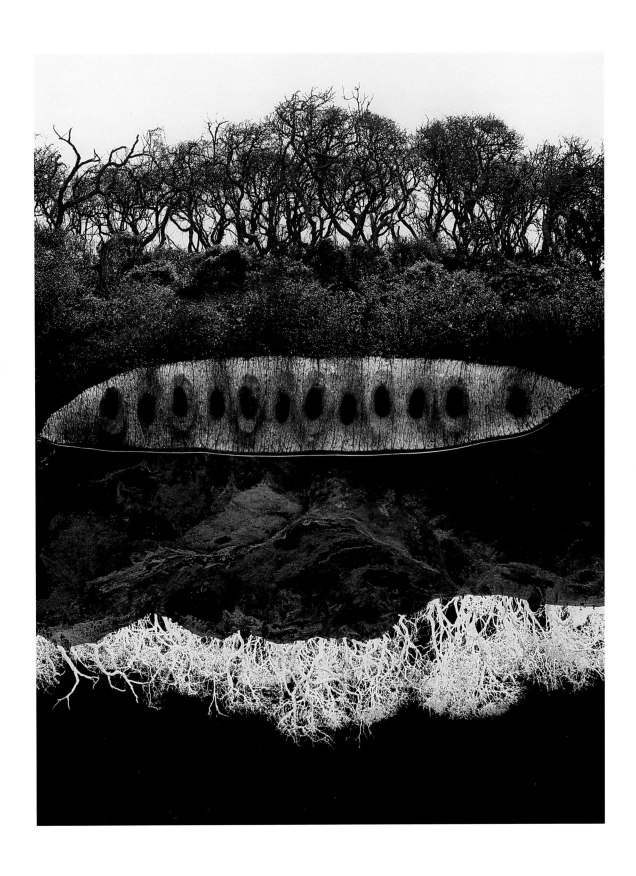

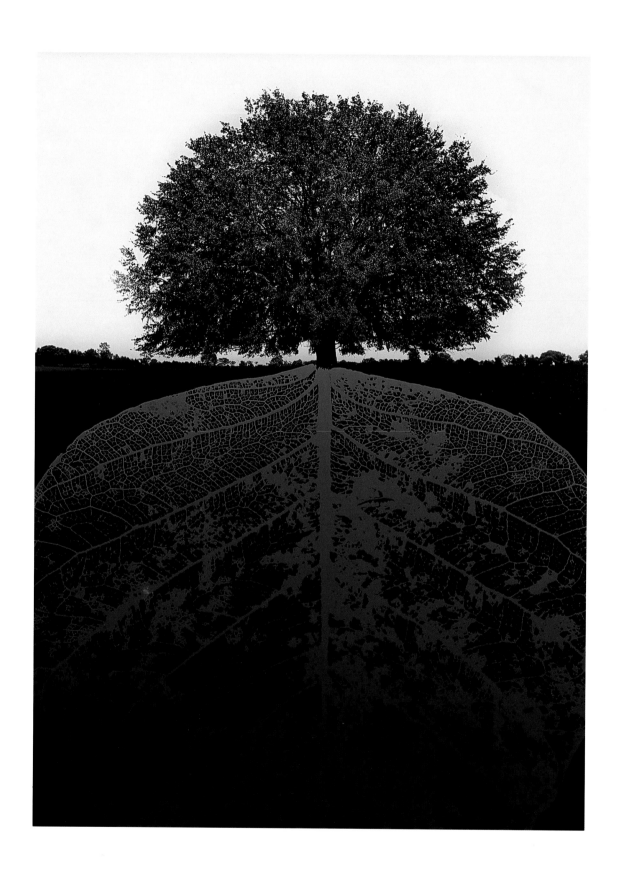

6 ∗ 1964

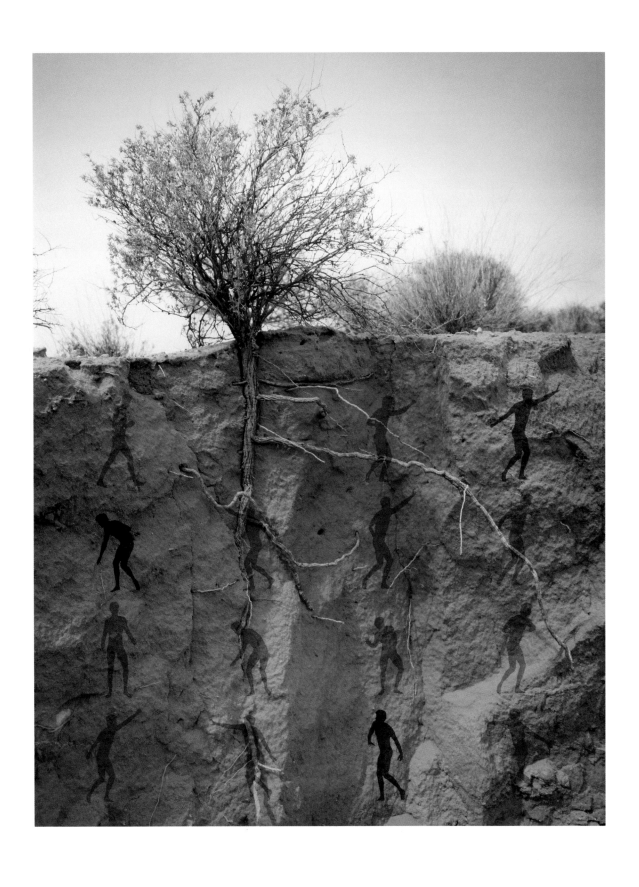

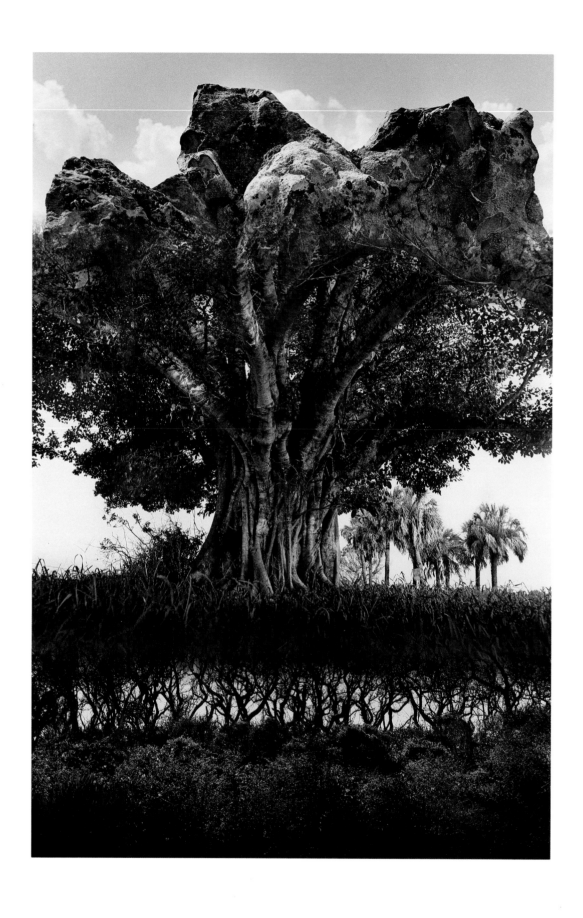

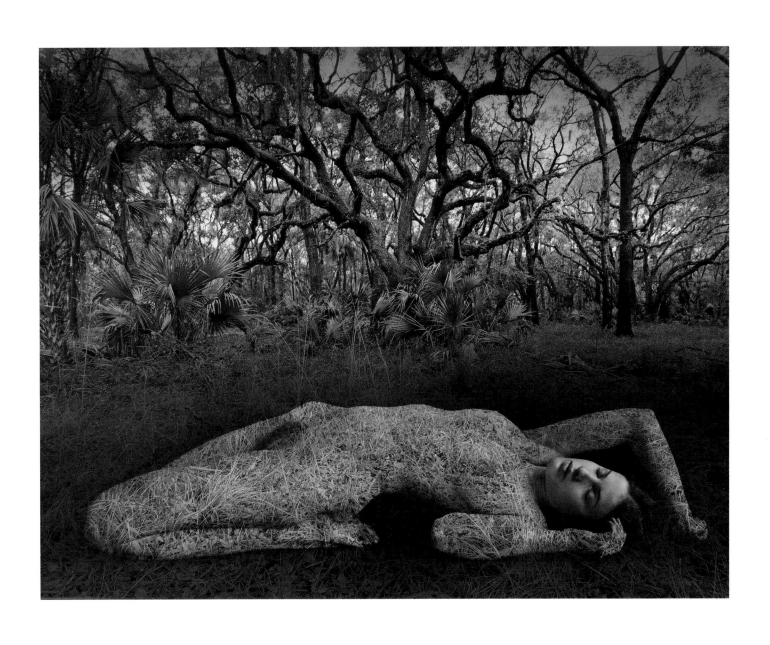

9 * 1983

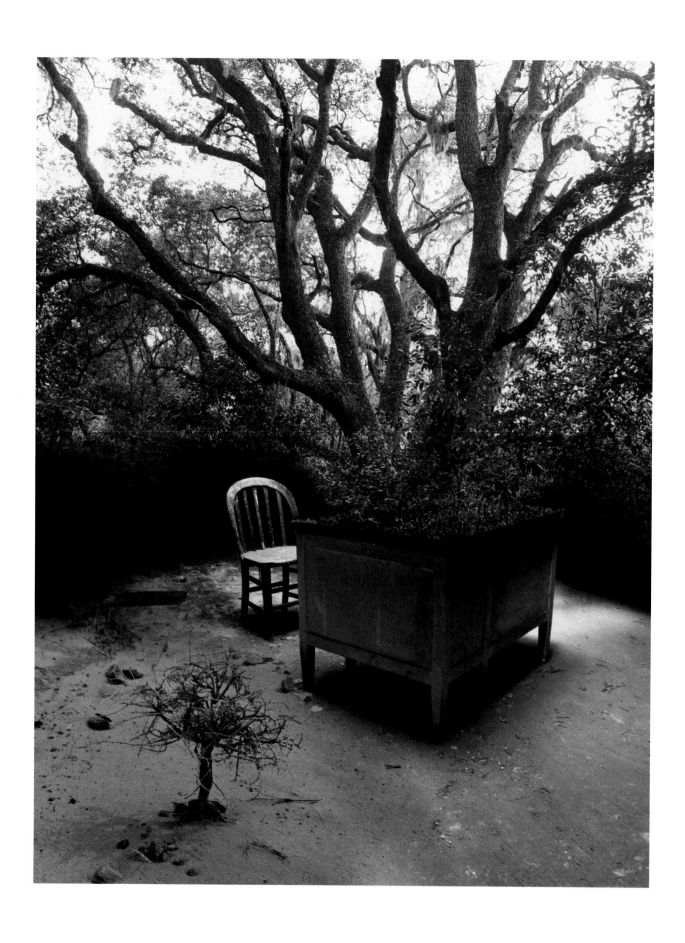

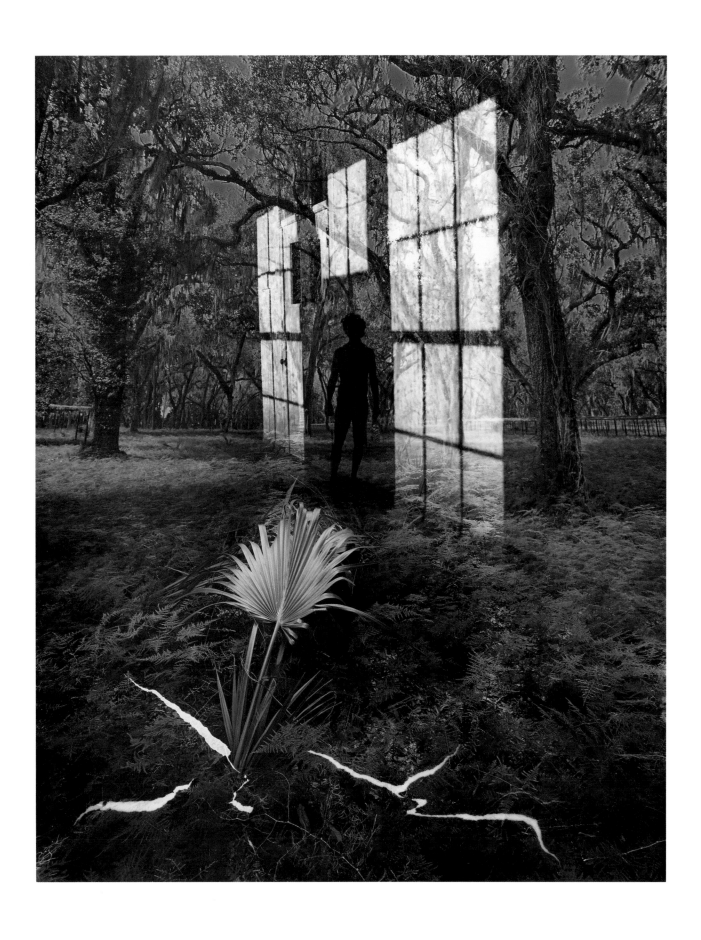

11 * 1978

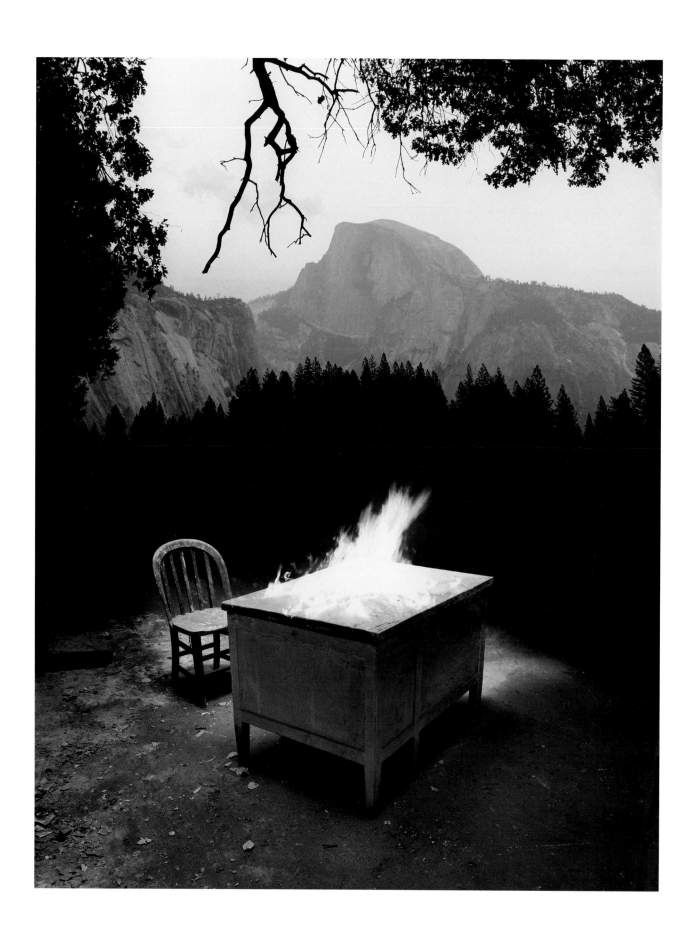

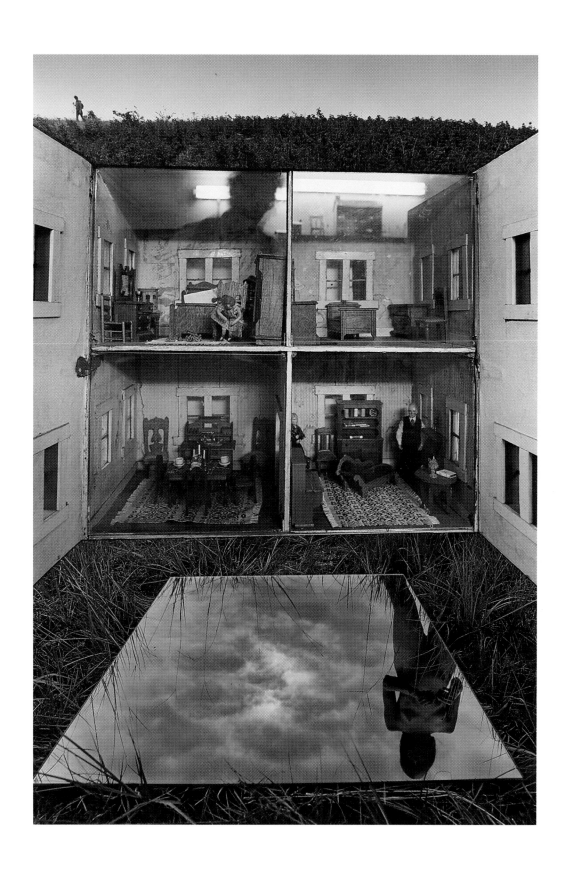

17　＊　1977

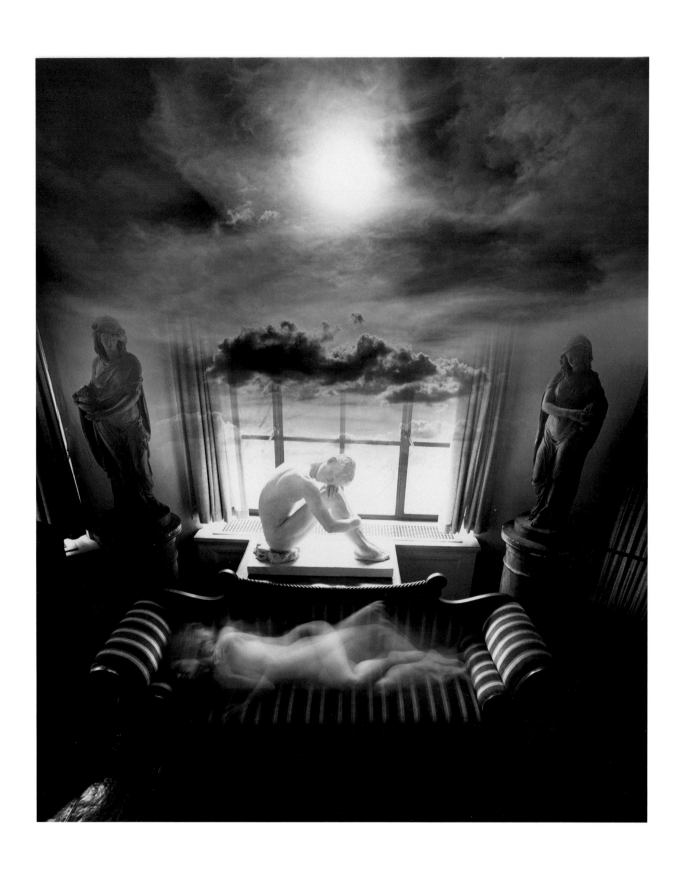

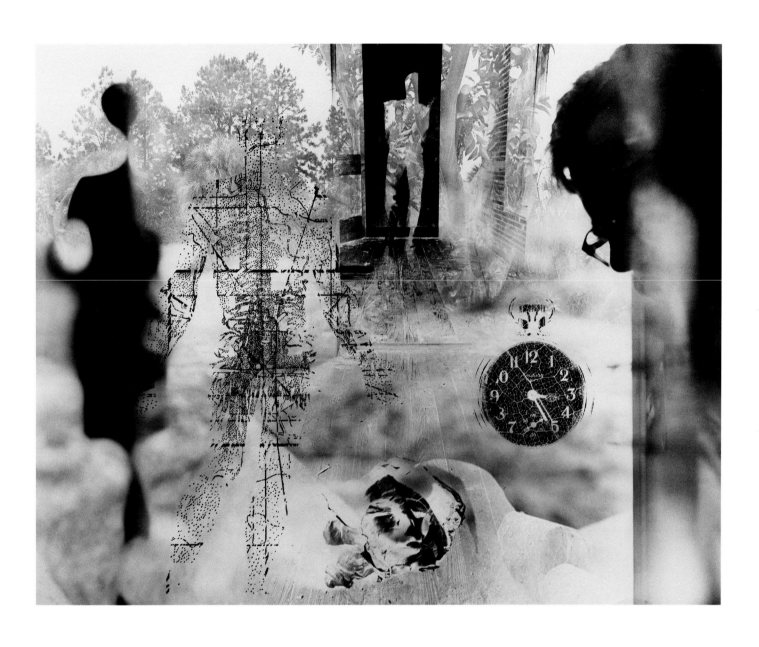

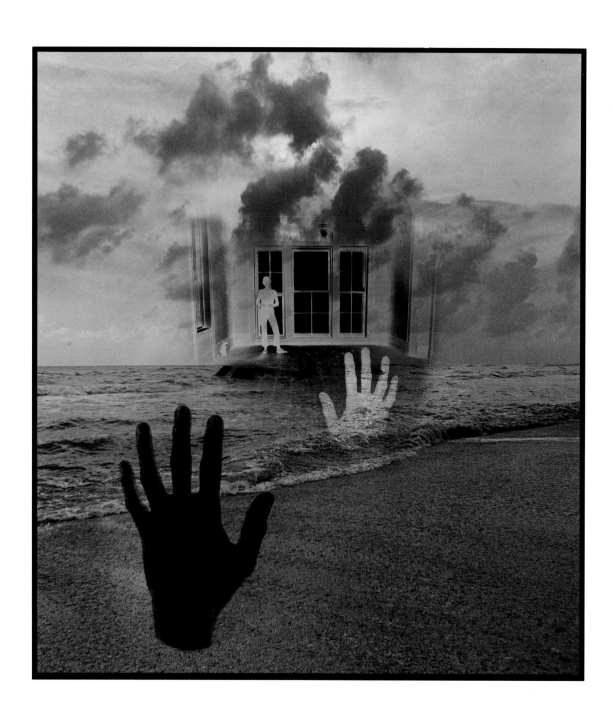

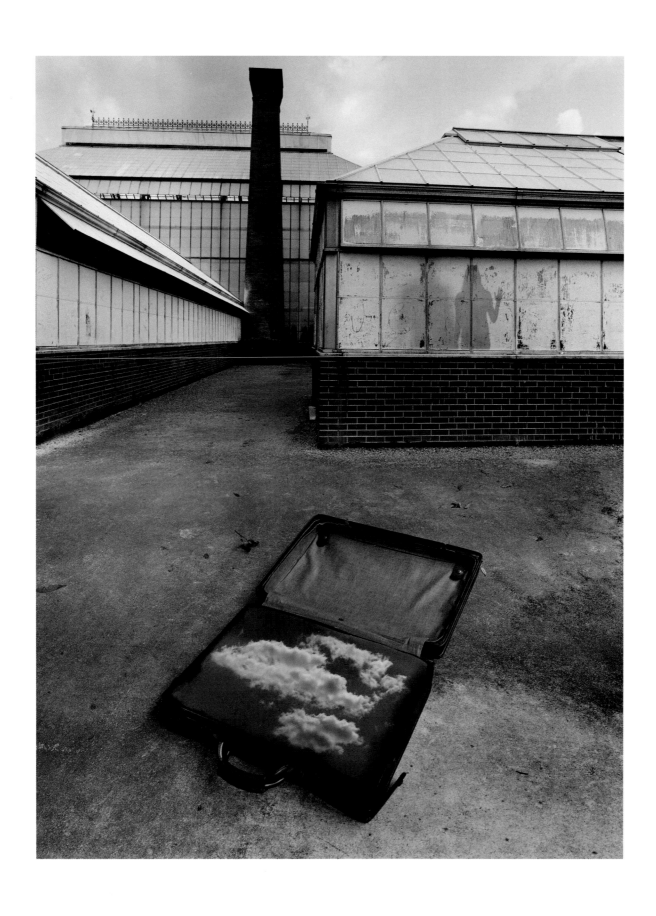

21 ∗ 1982

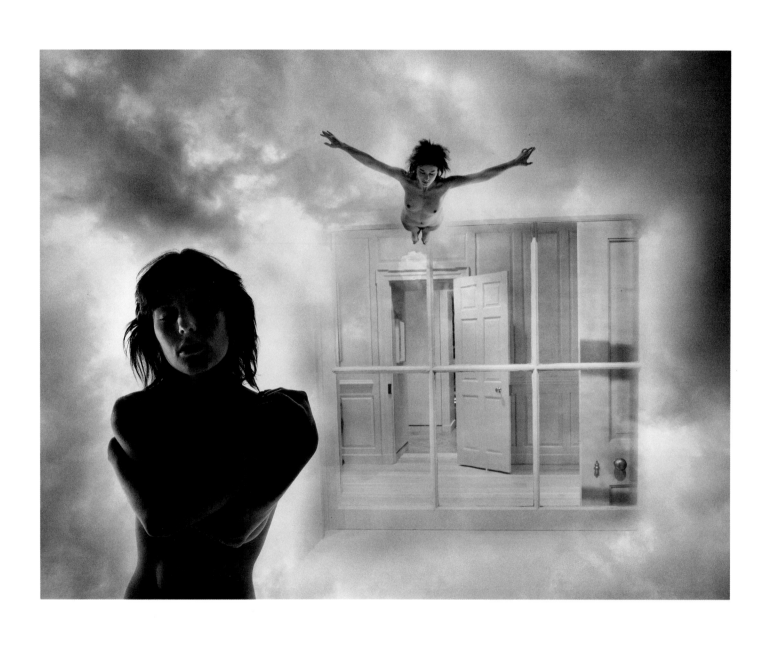

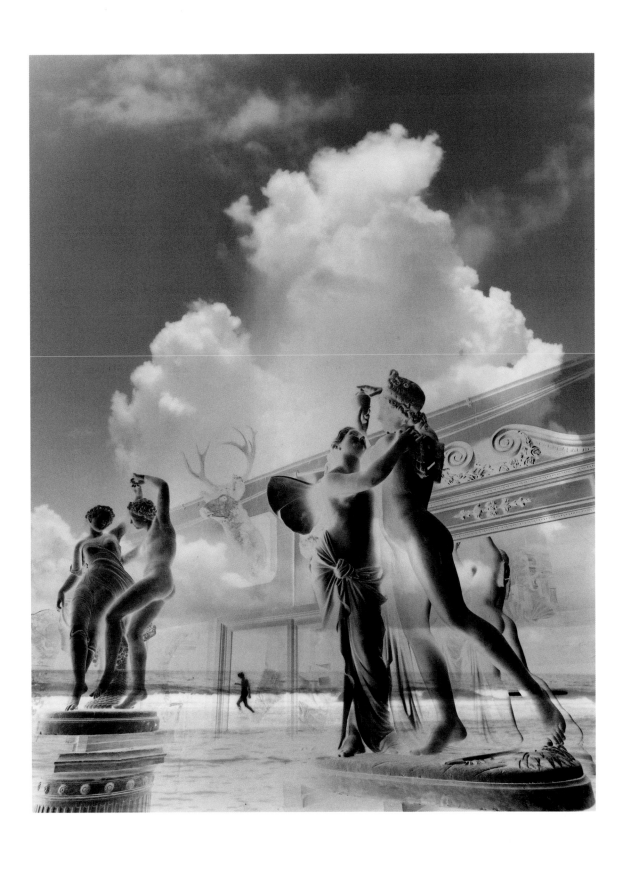

23 * 1980

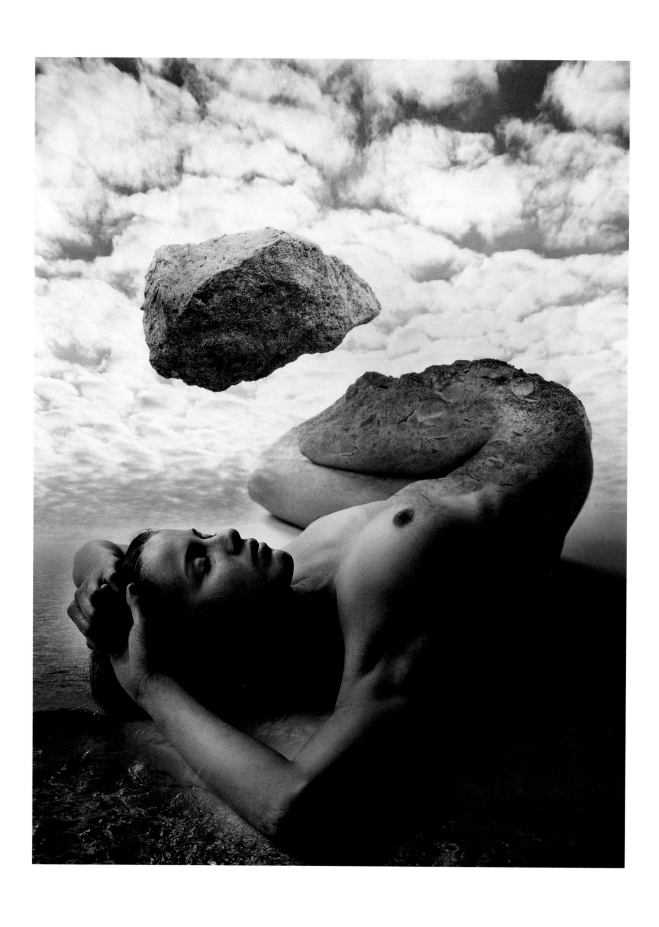

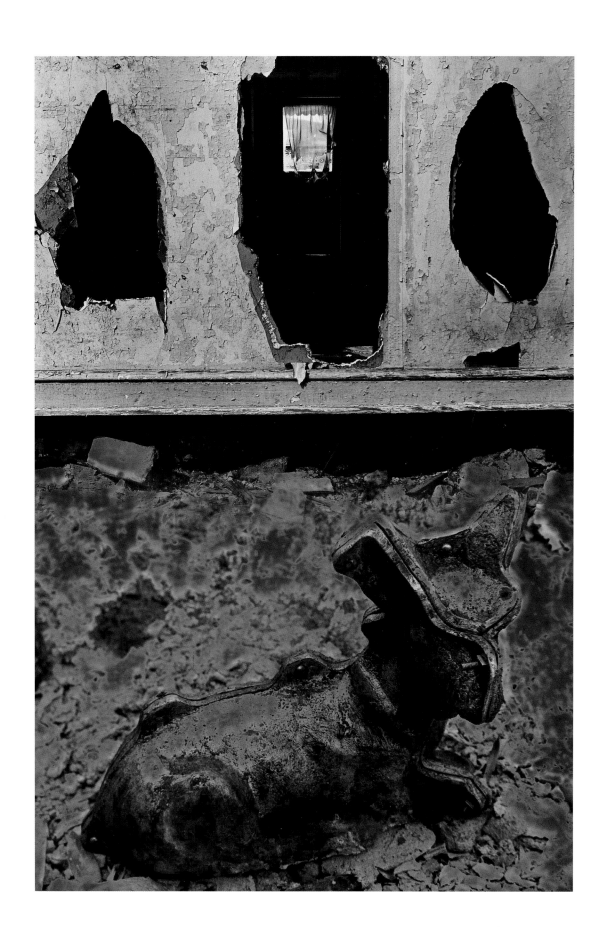

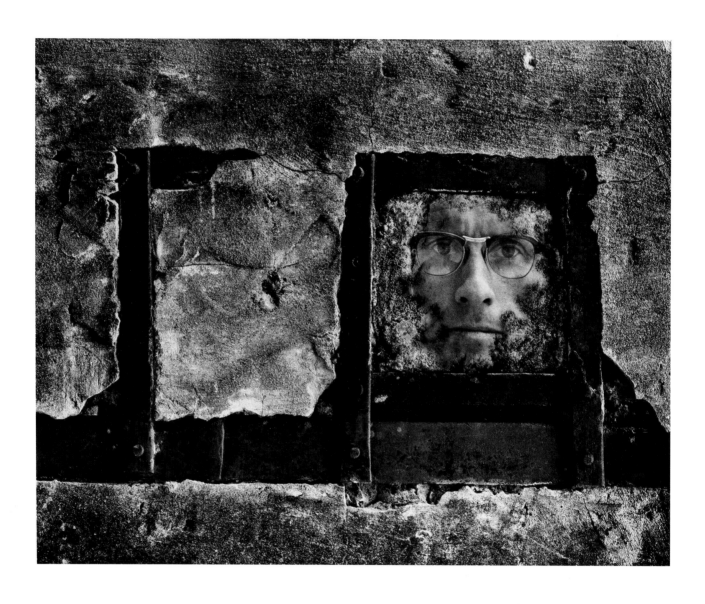

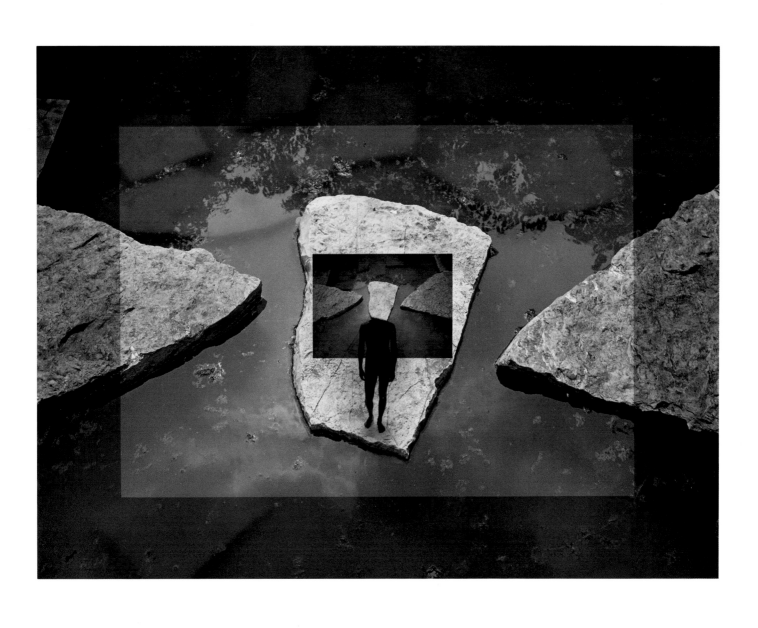

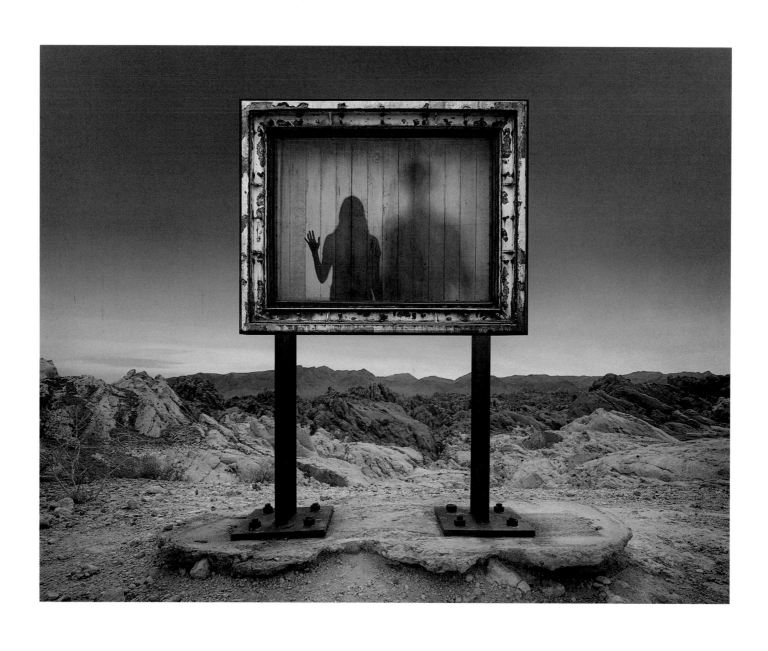

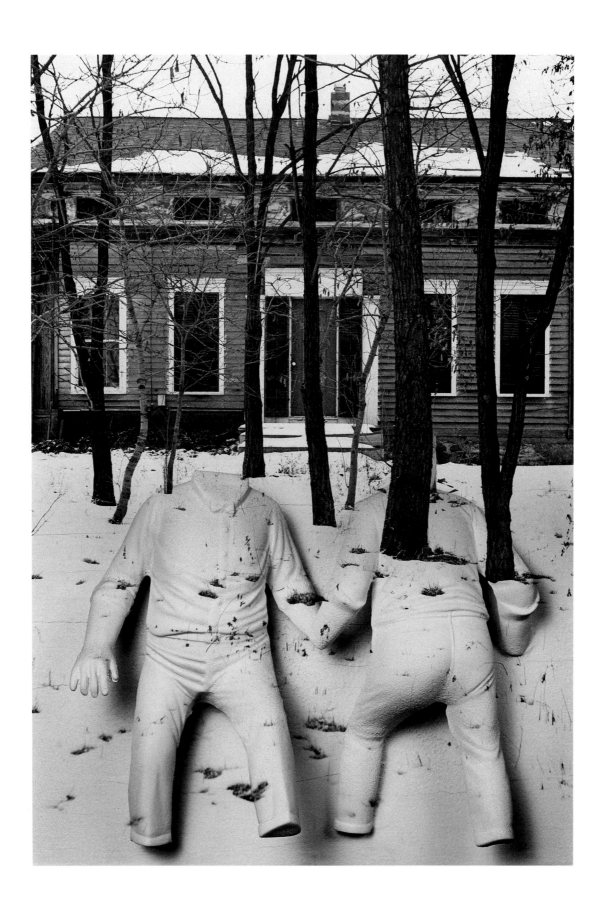

33 * 1968

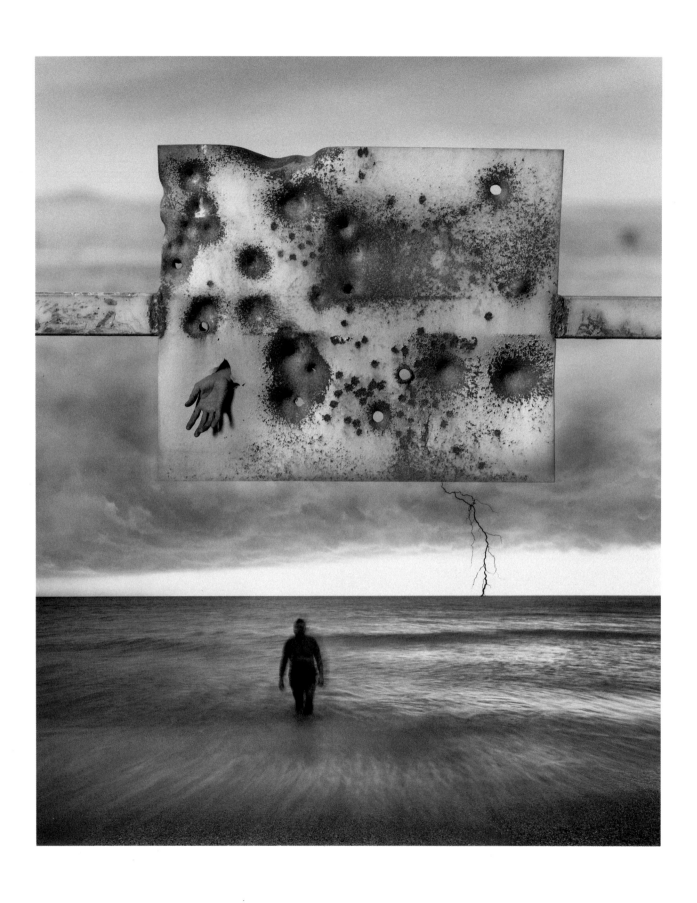

34 * 1990

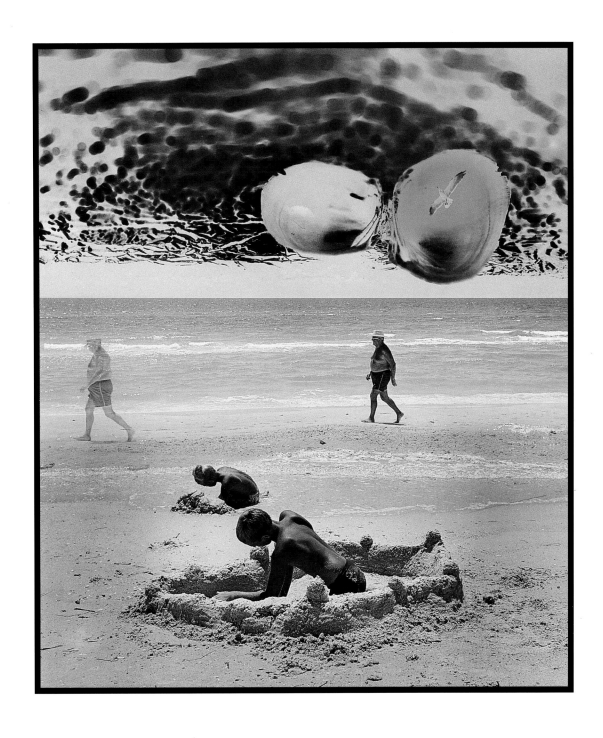

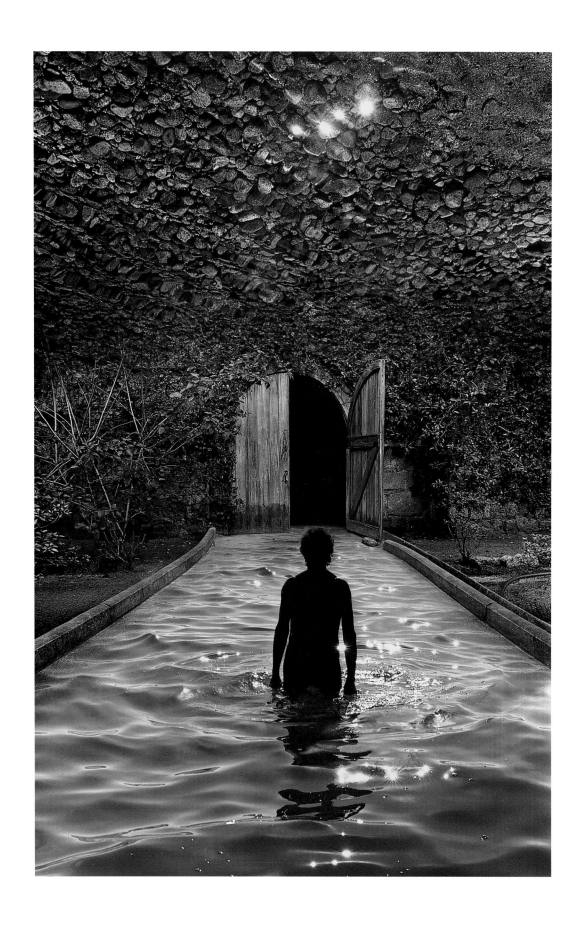

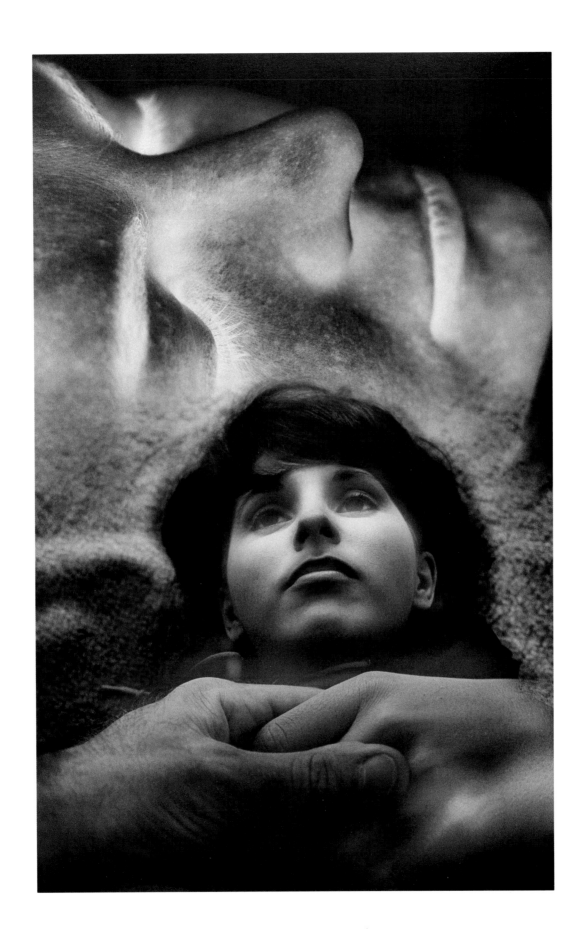

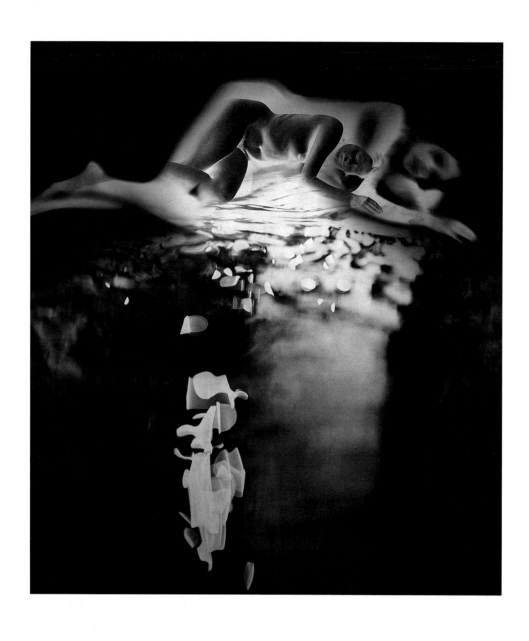

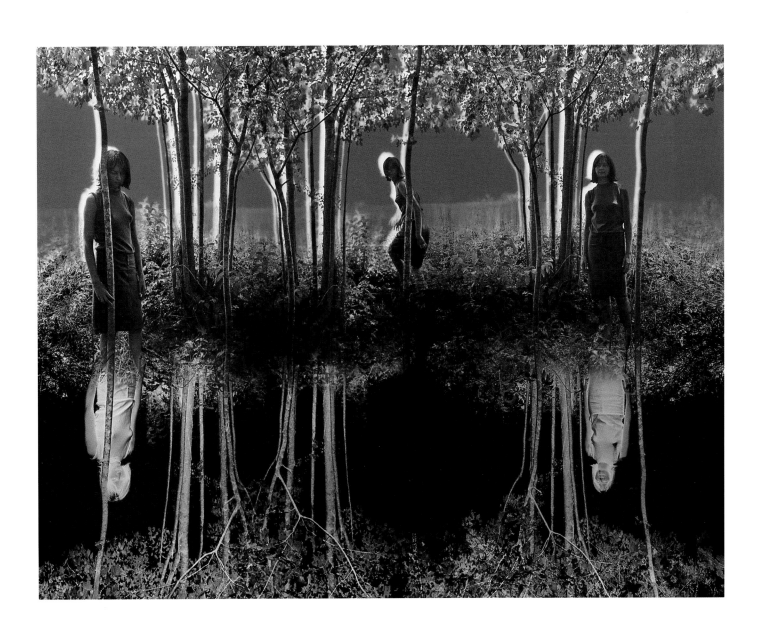

4 3 ✳ *Small Woods Where I Met Myself* (final version) 1 9 6 7

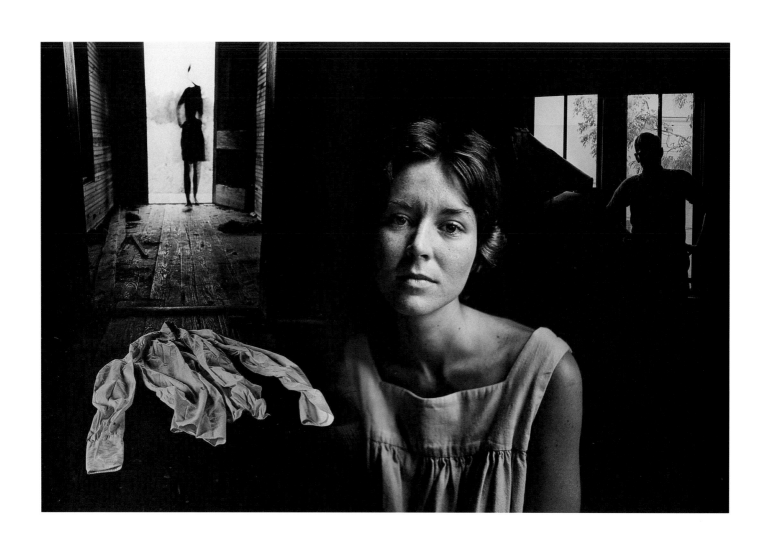

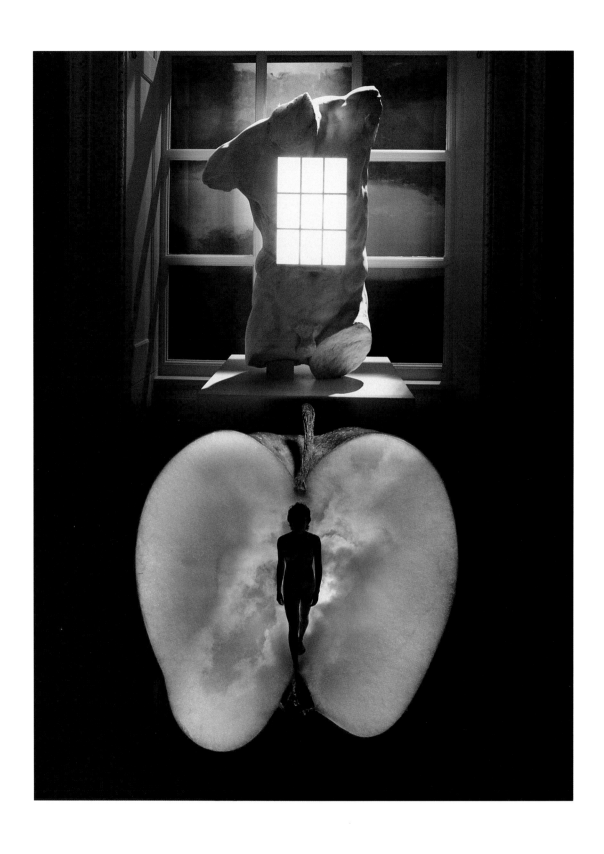

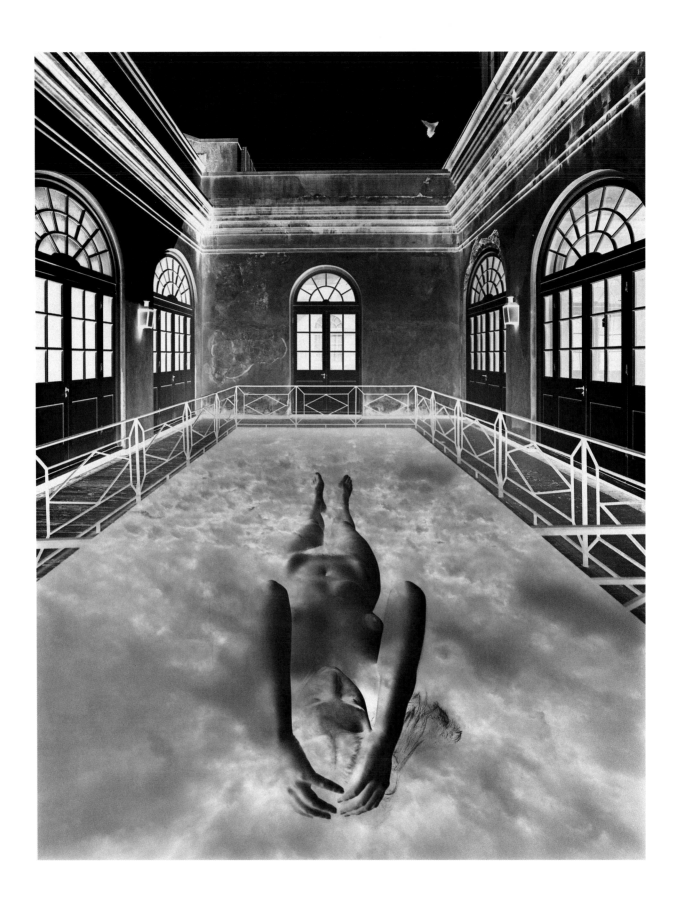

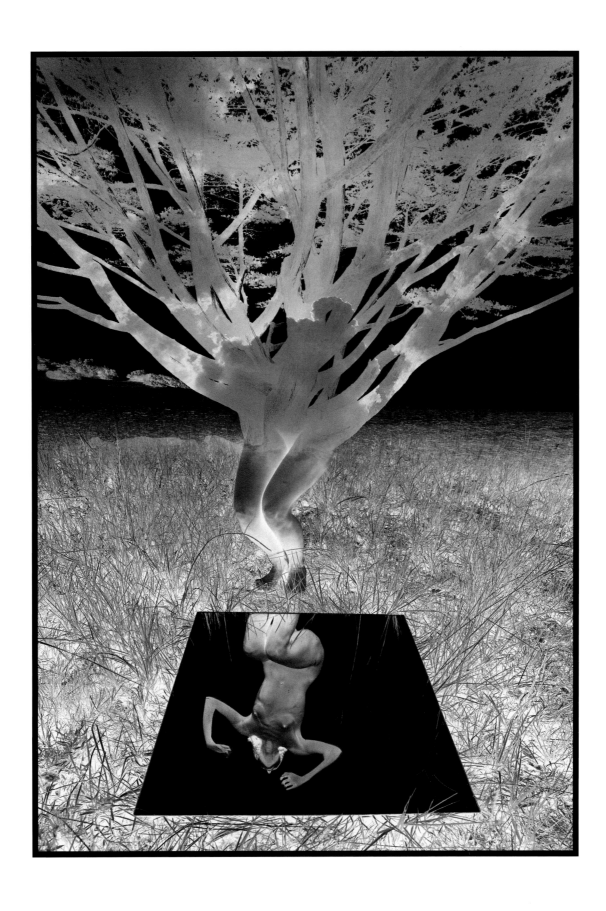

47 * 1976

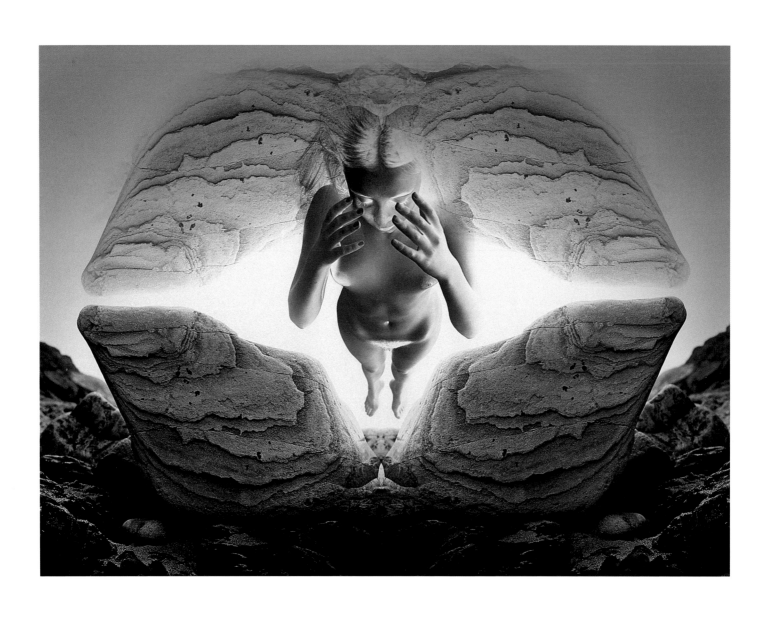

49　*　1985

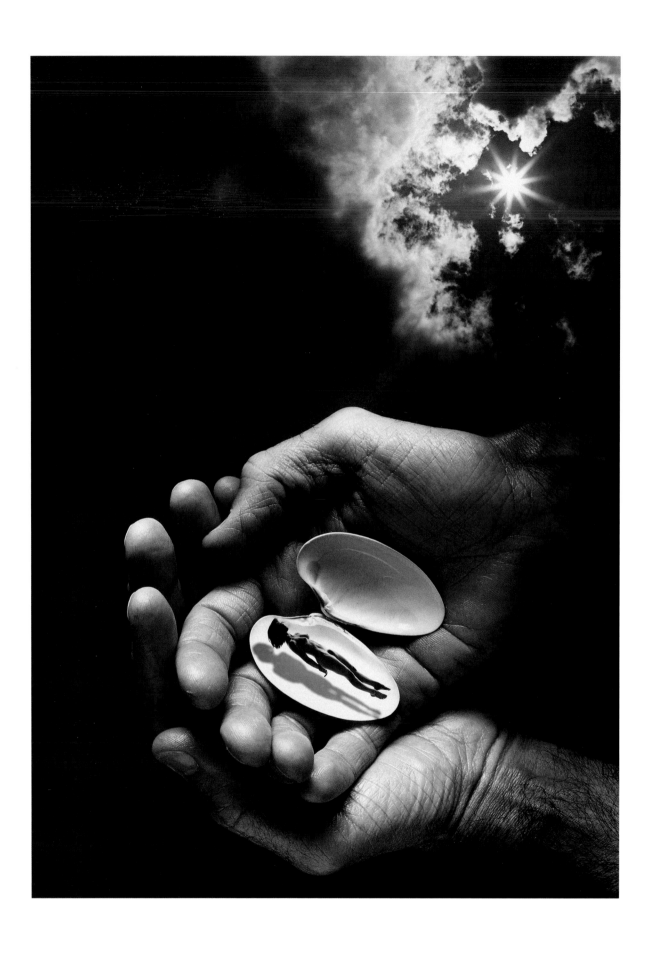

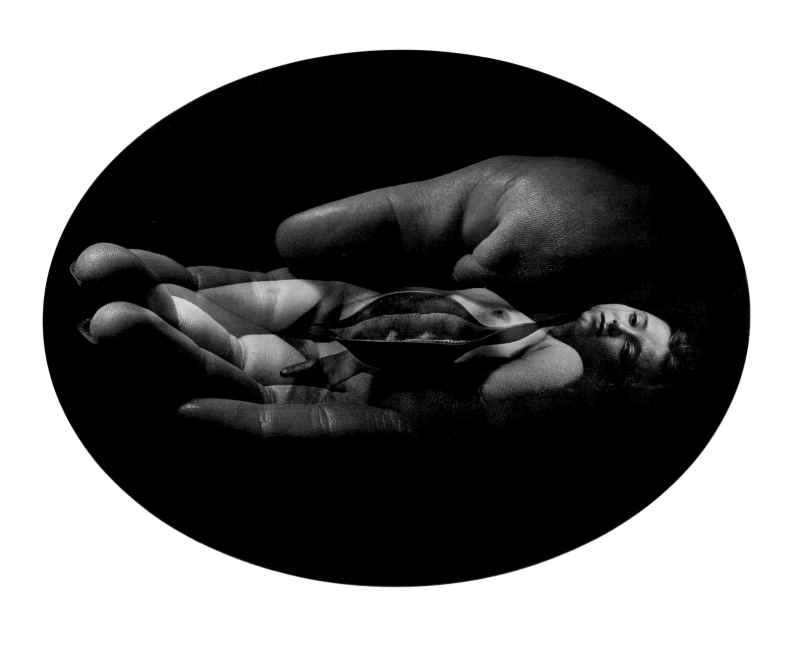

51 * 1972

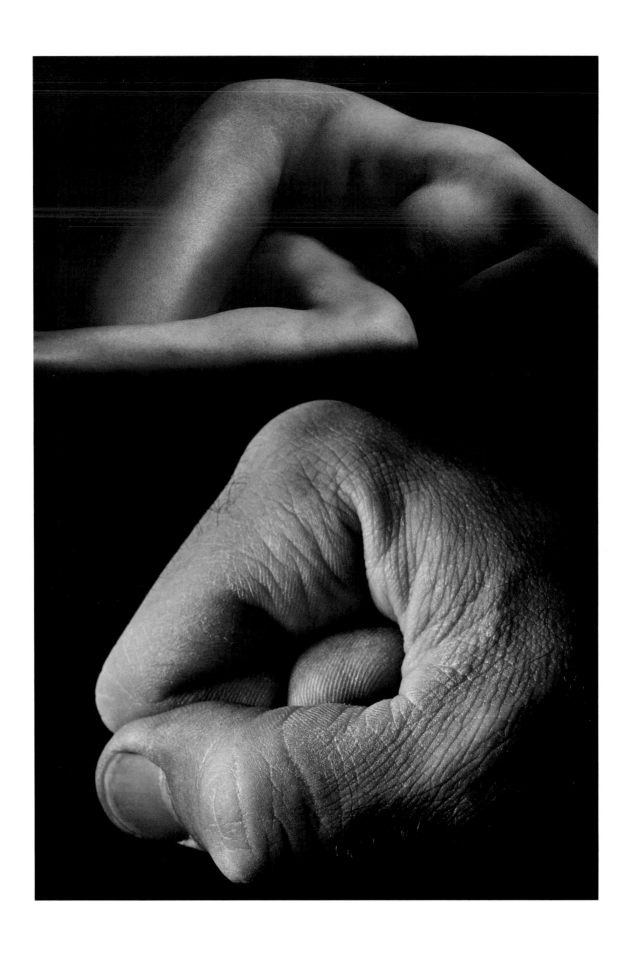

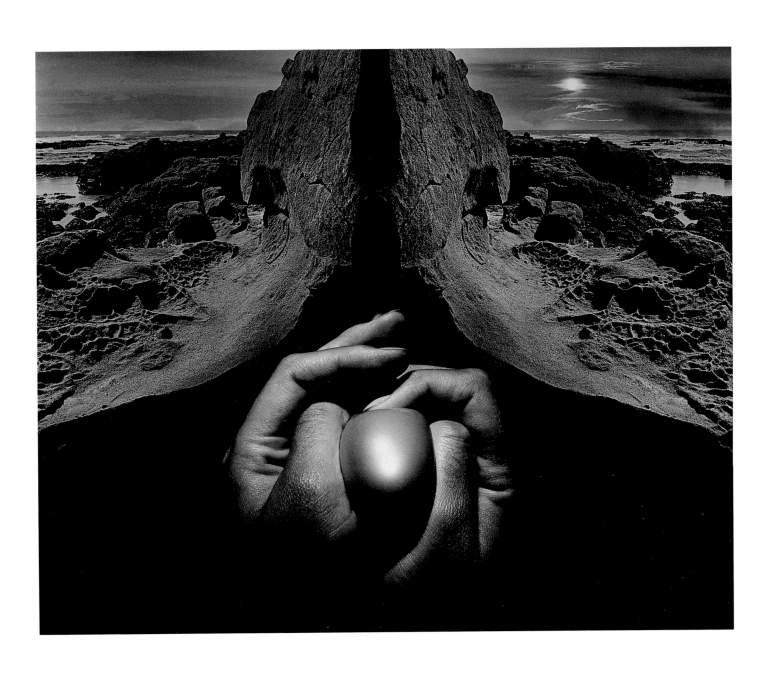

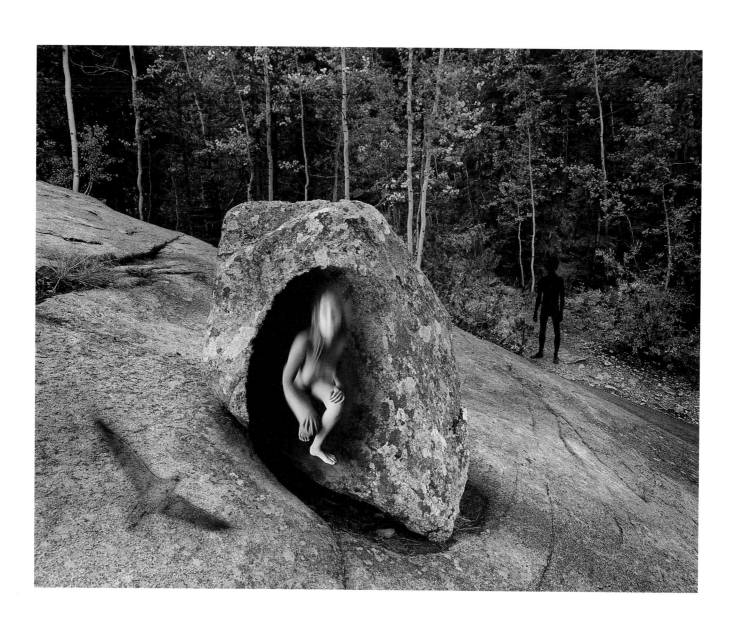

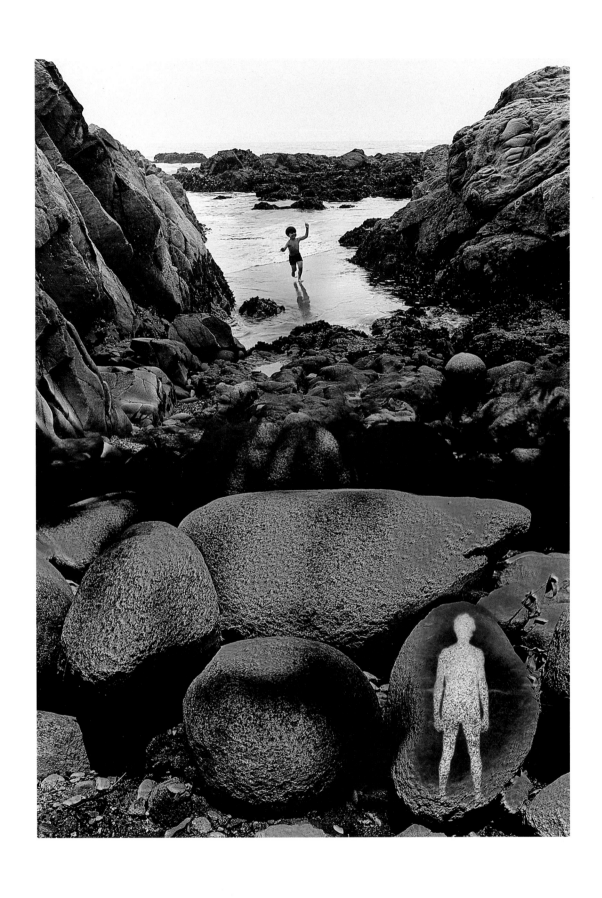

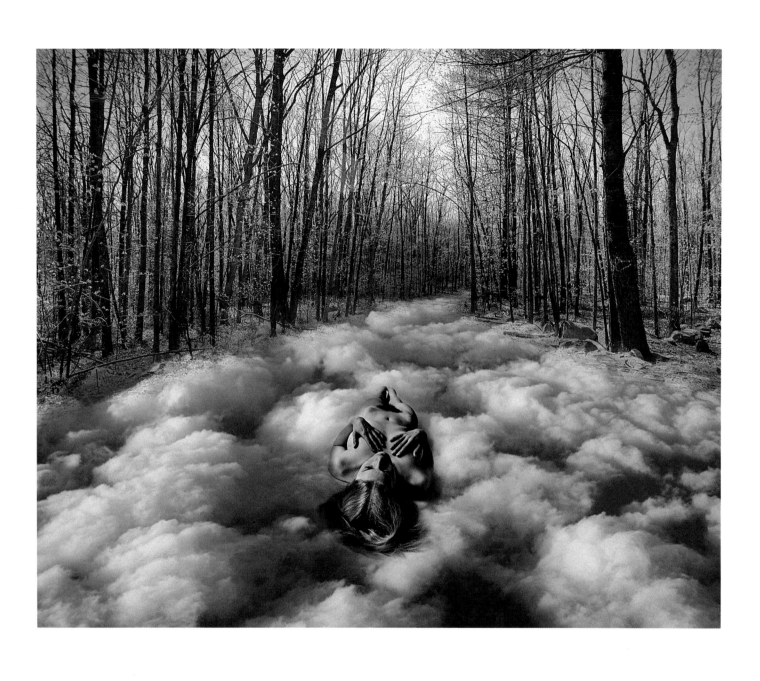

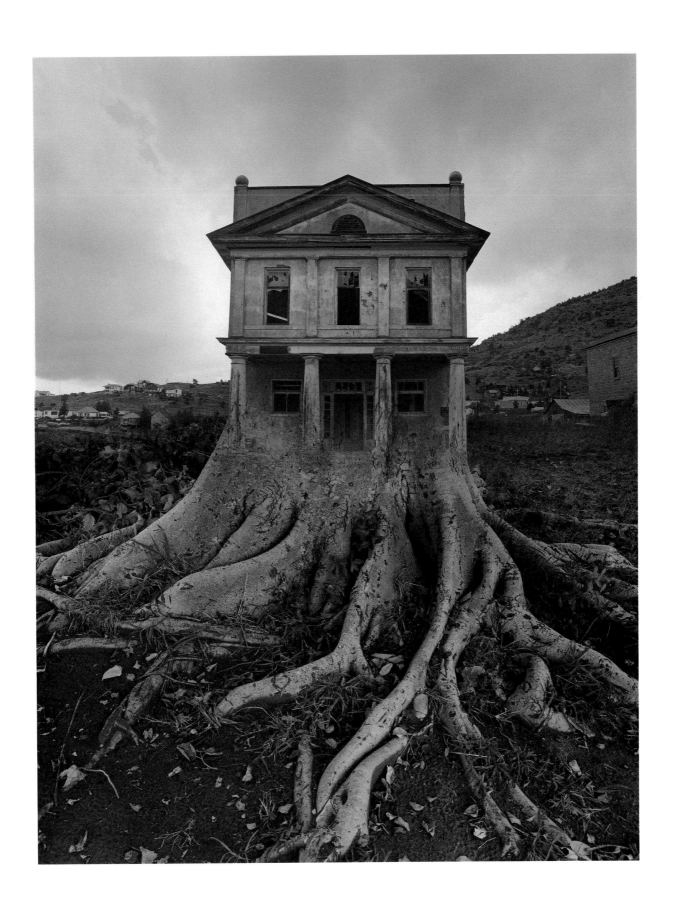

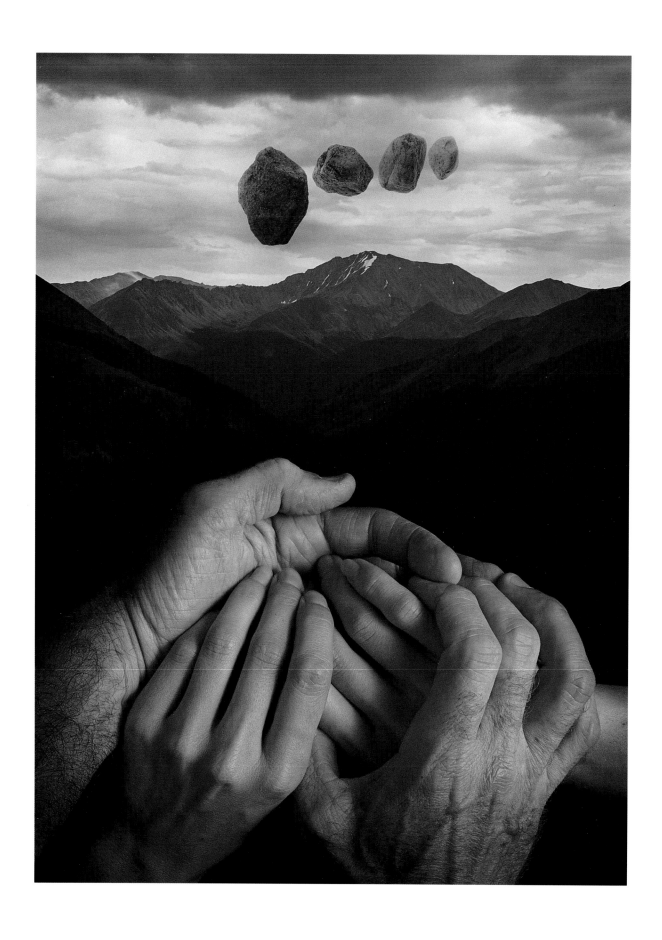

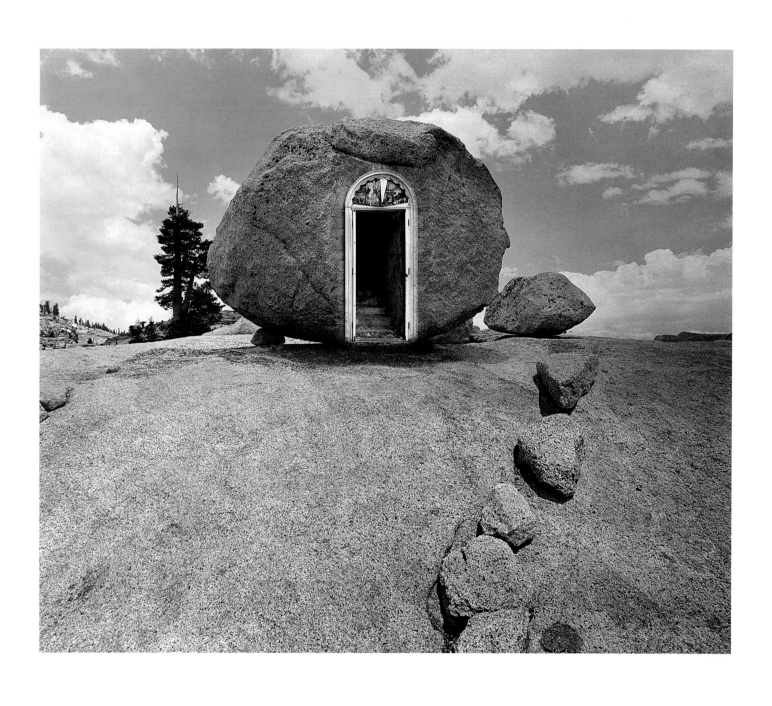

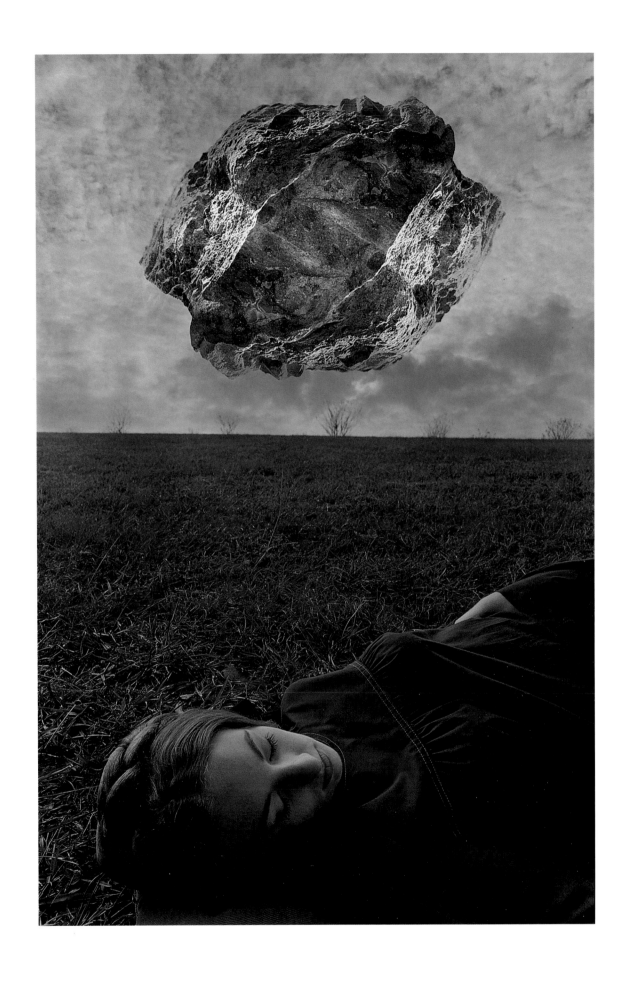

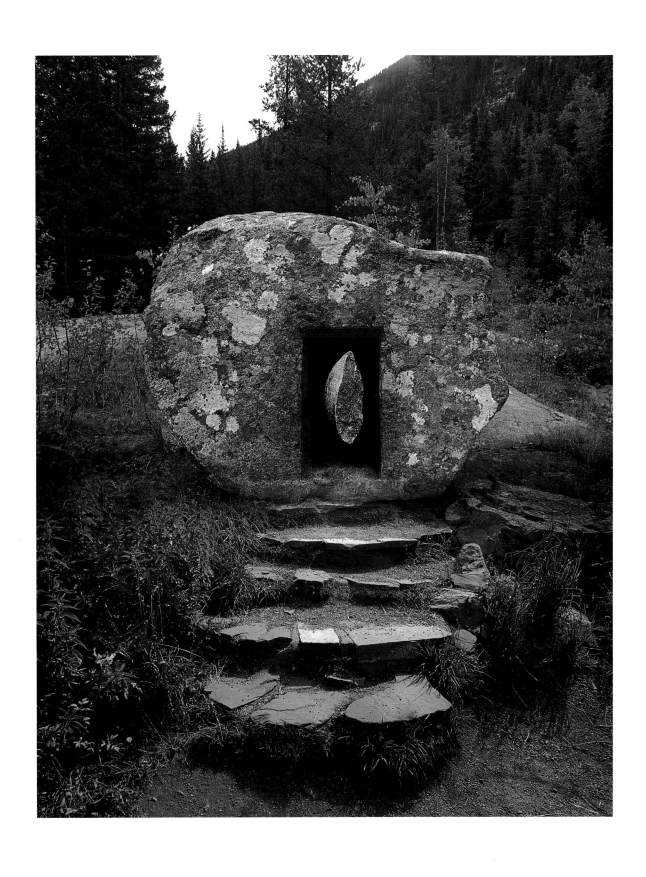

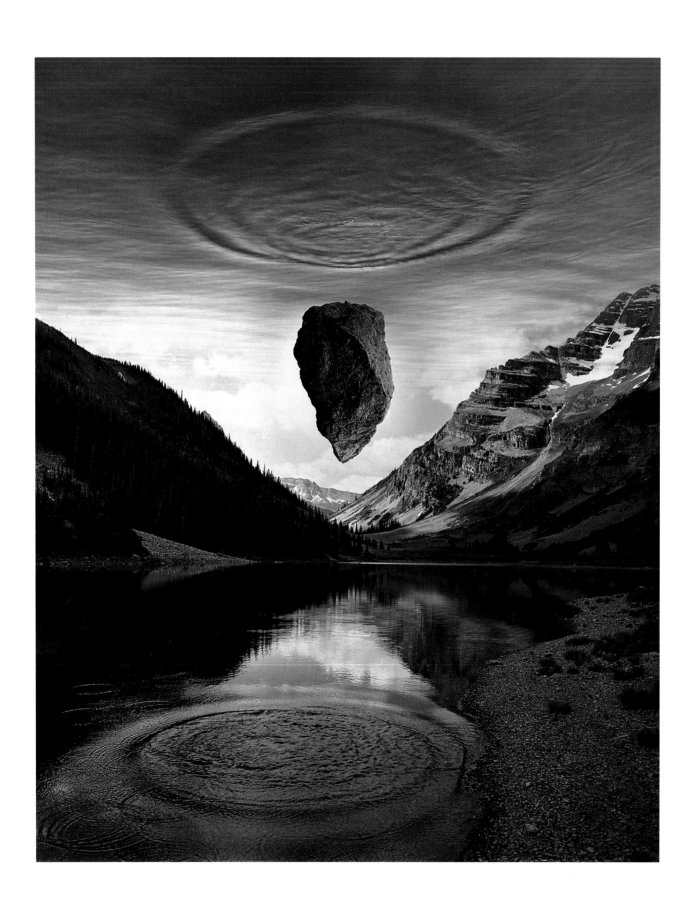

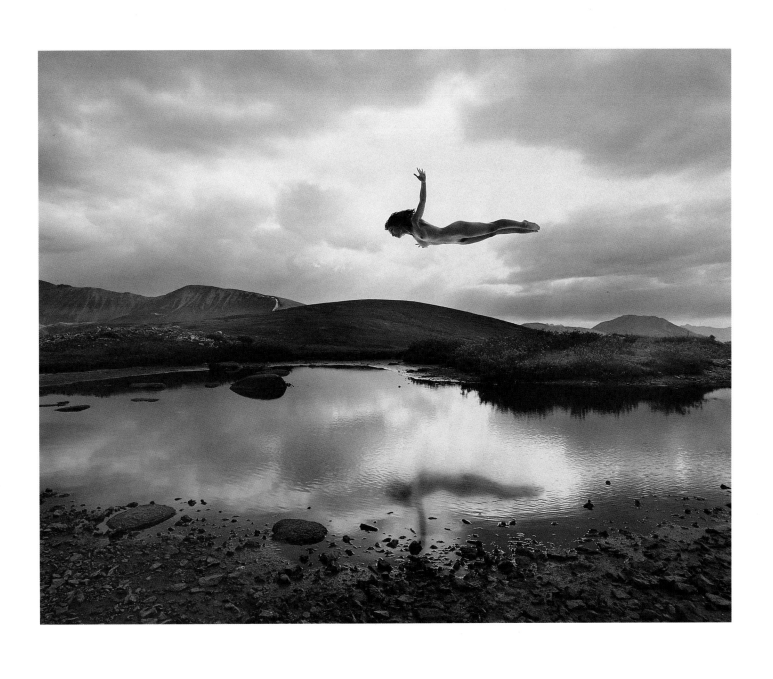

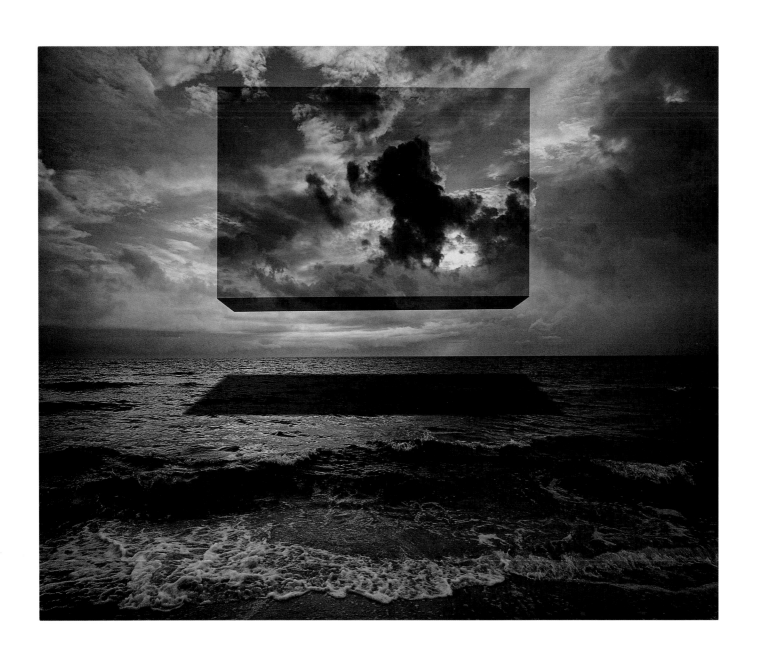

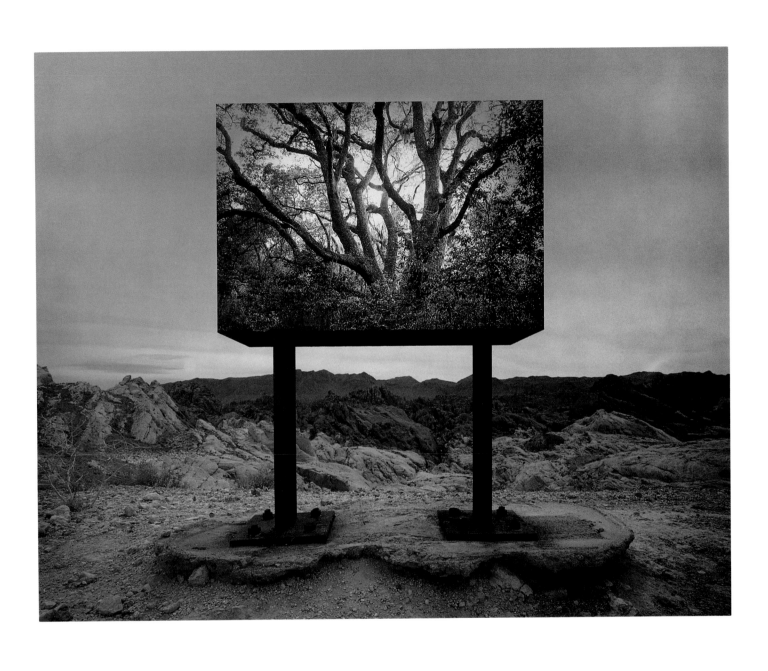

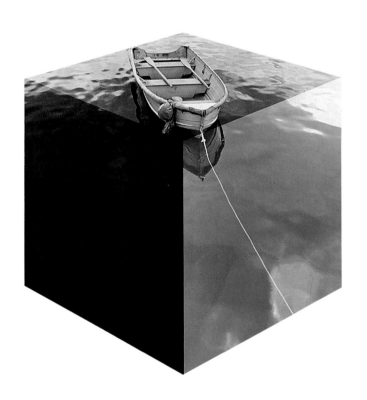

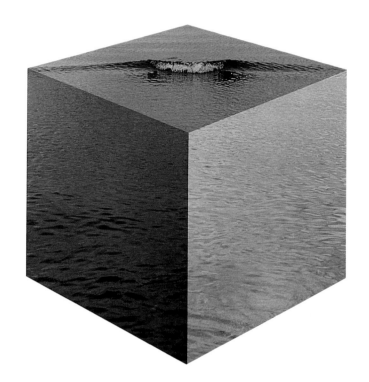

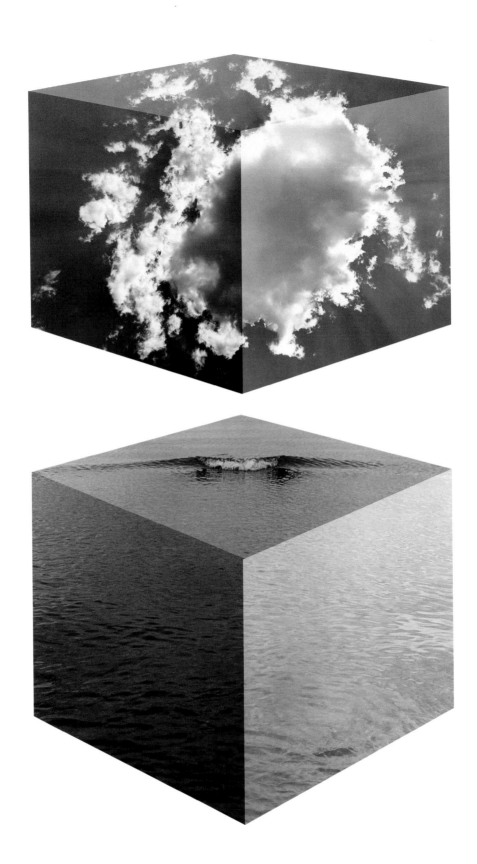

71 * 1983

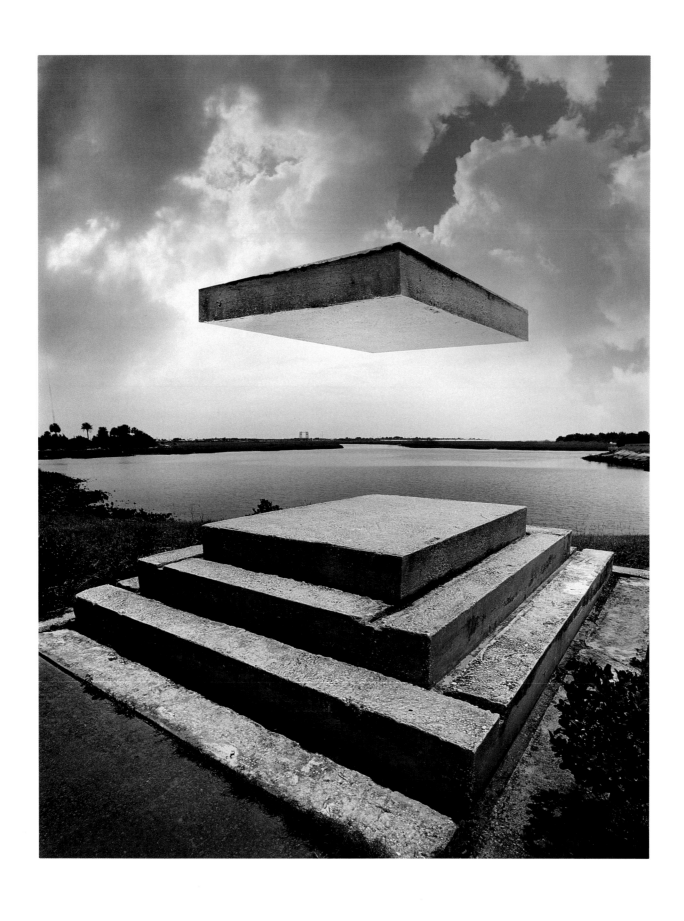

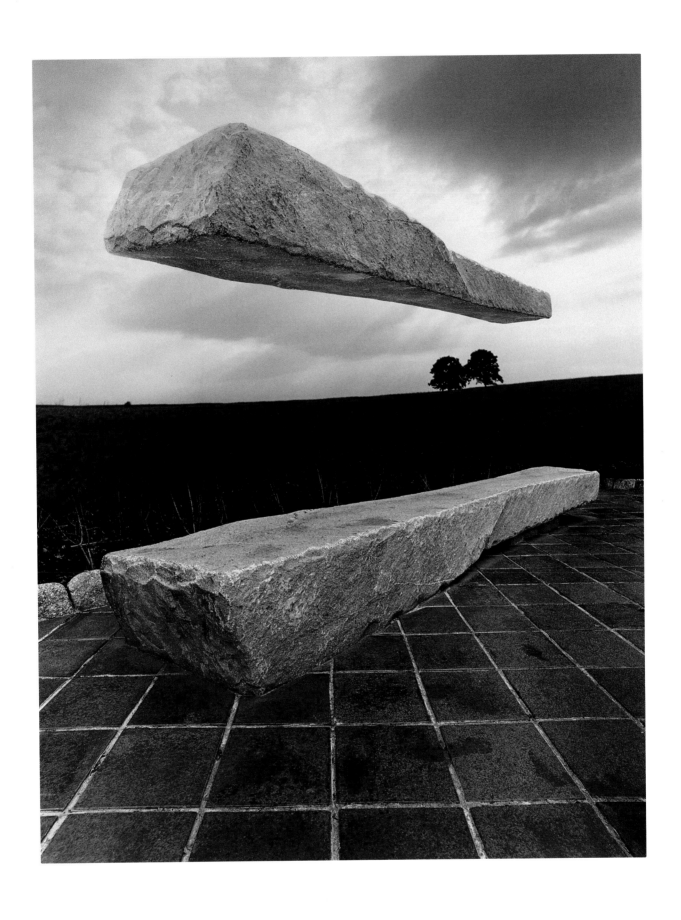

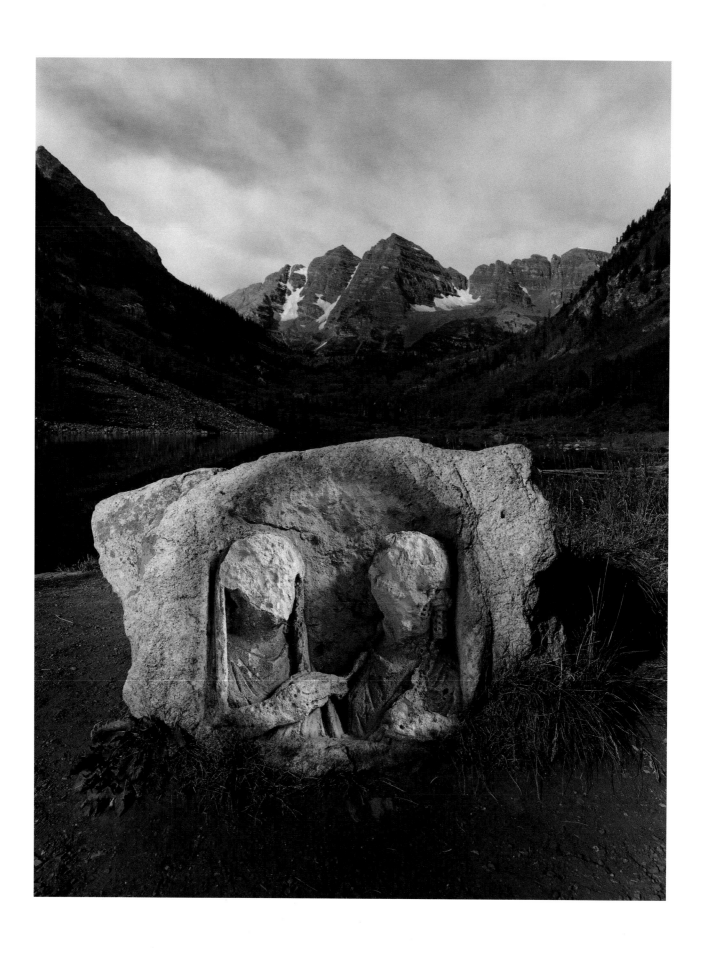

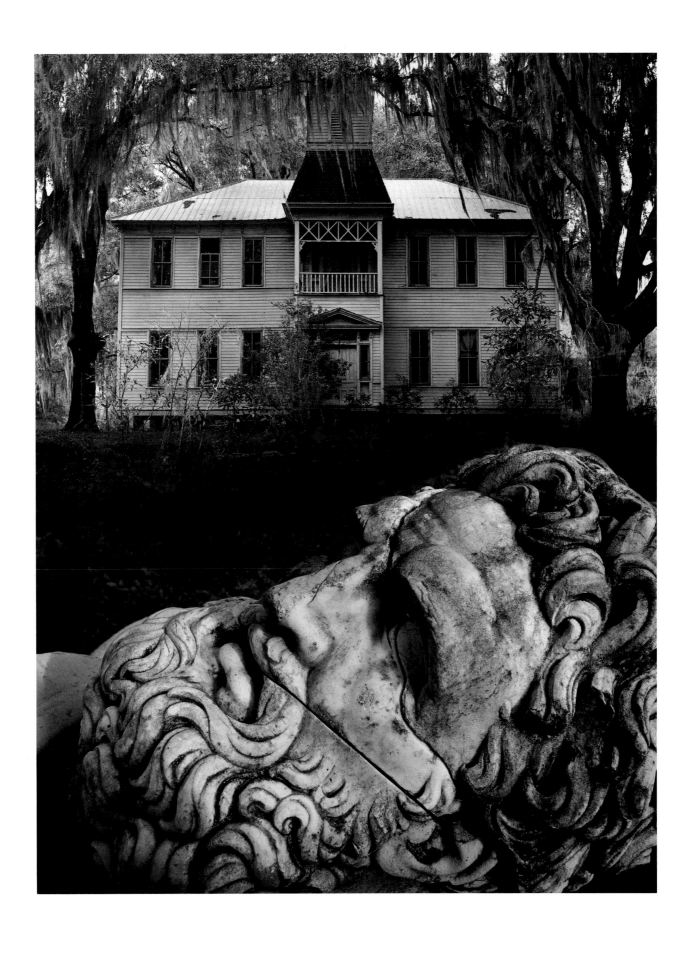

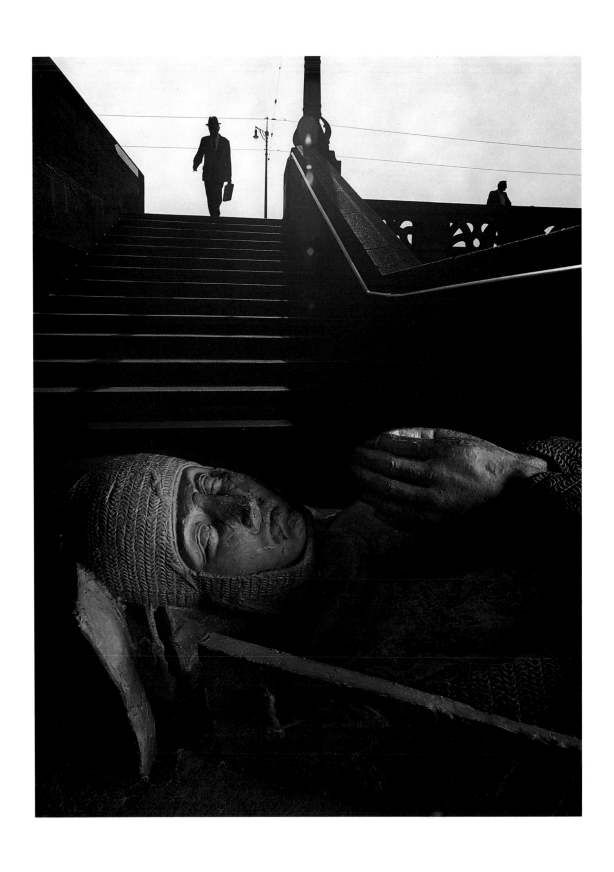

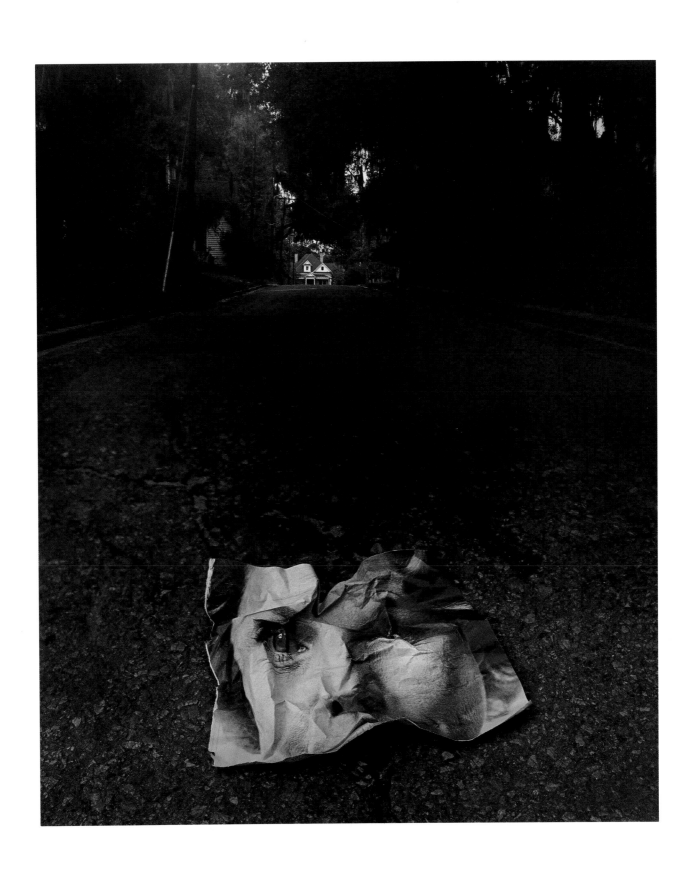

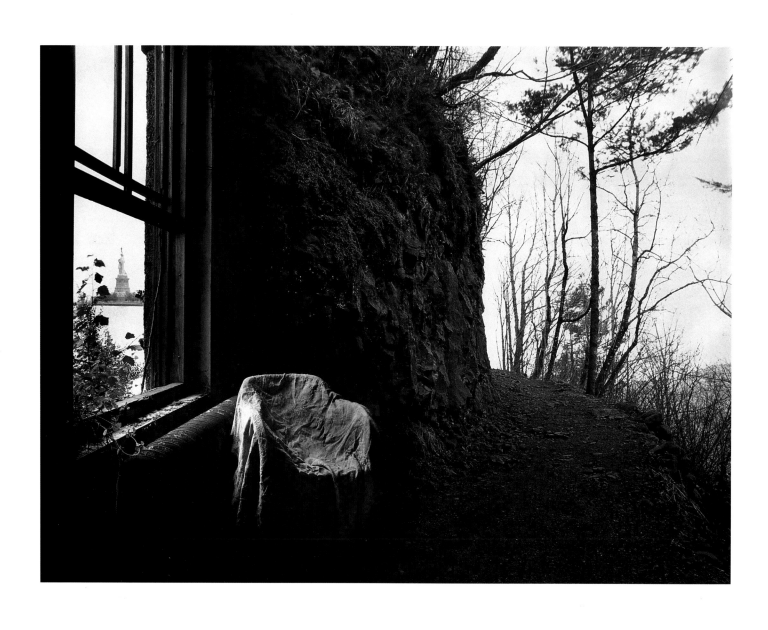

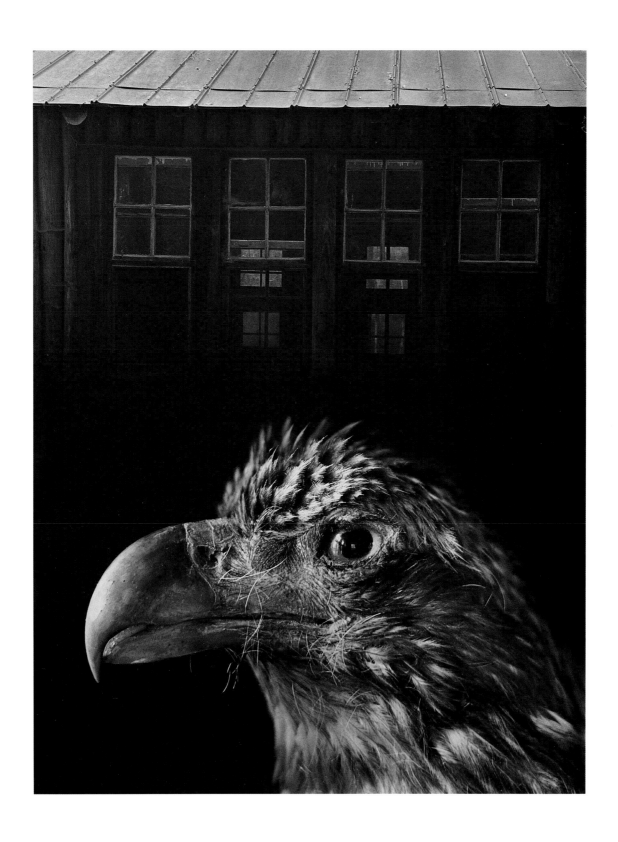

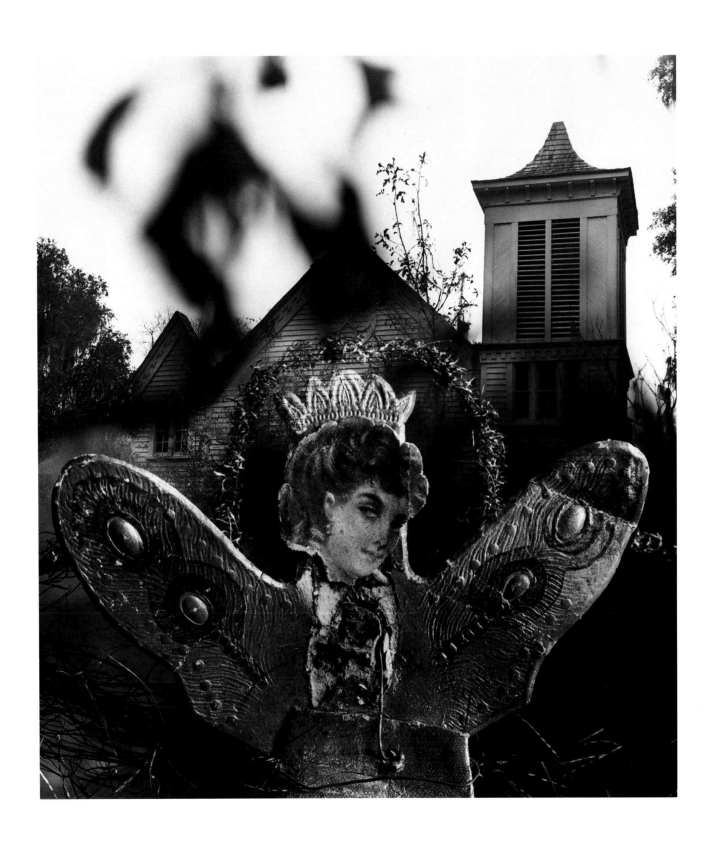

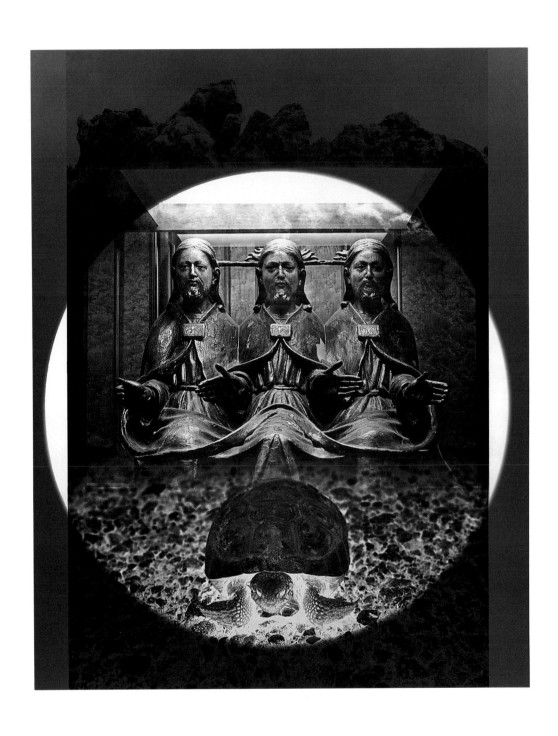

81 ＊ *Turtle Blessing* 1 9 6 8

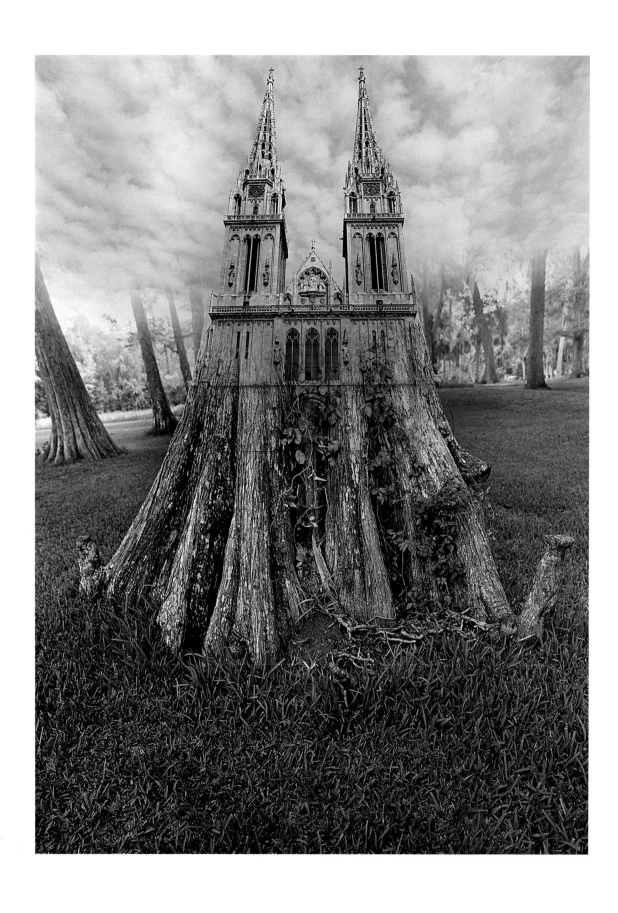

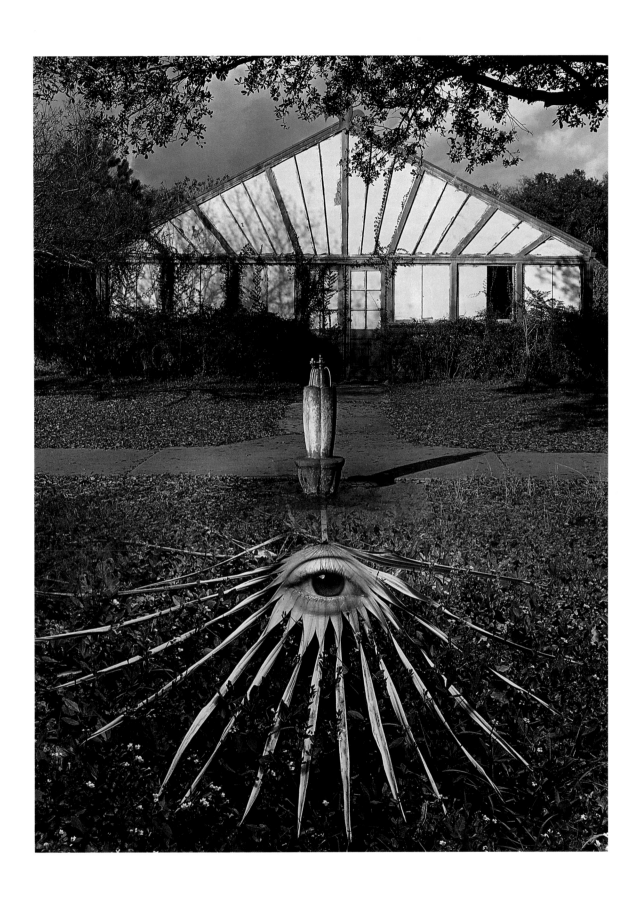

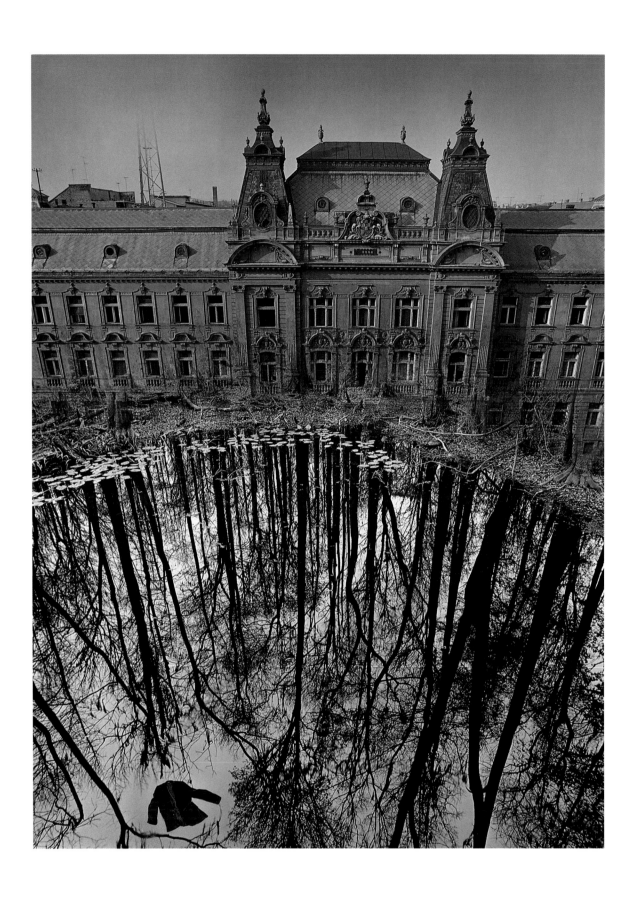

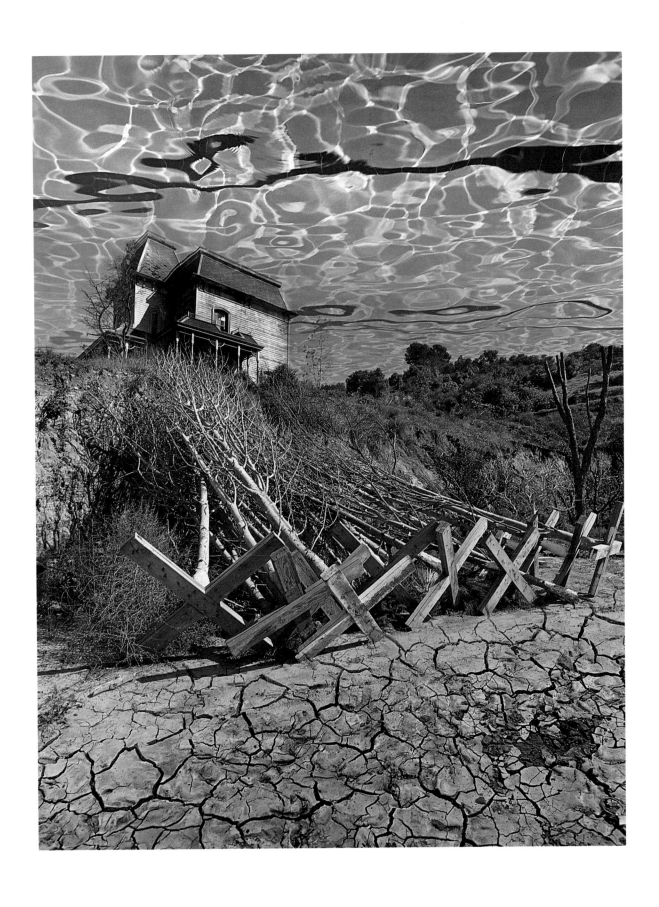

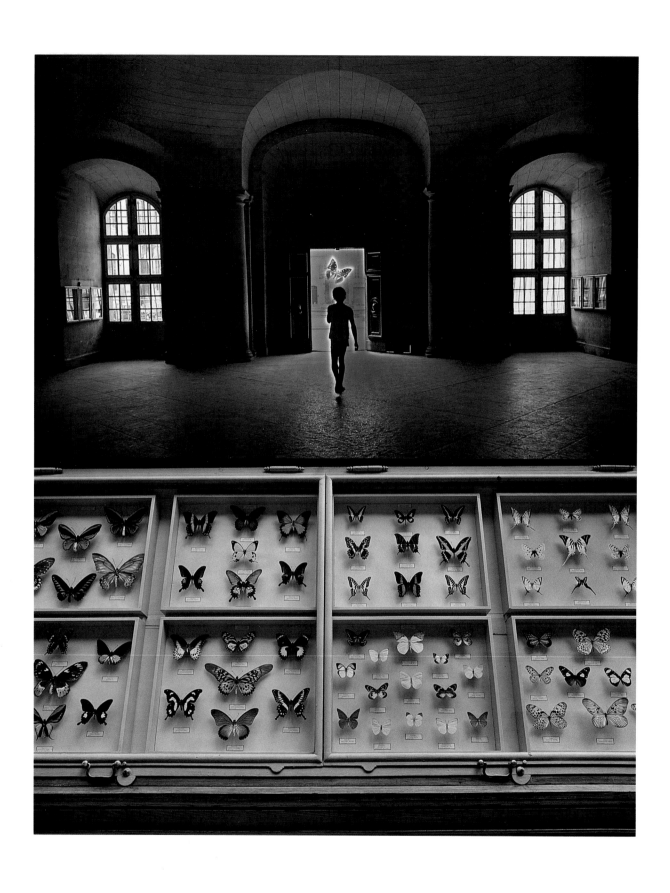

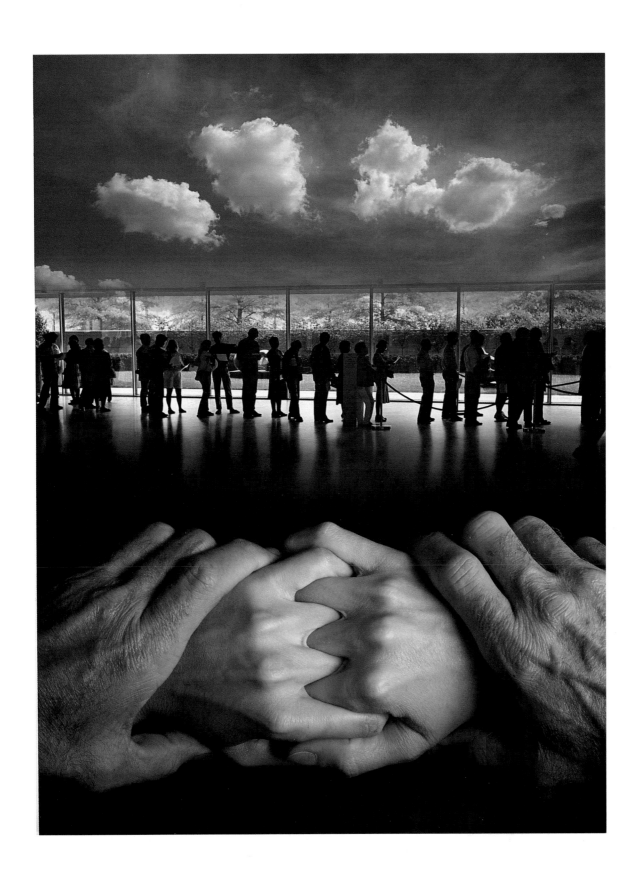

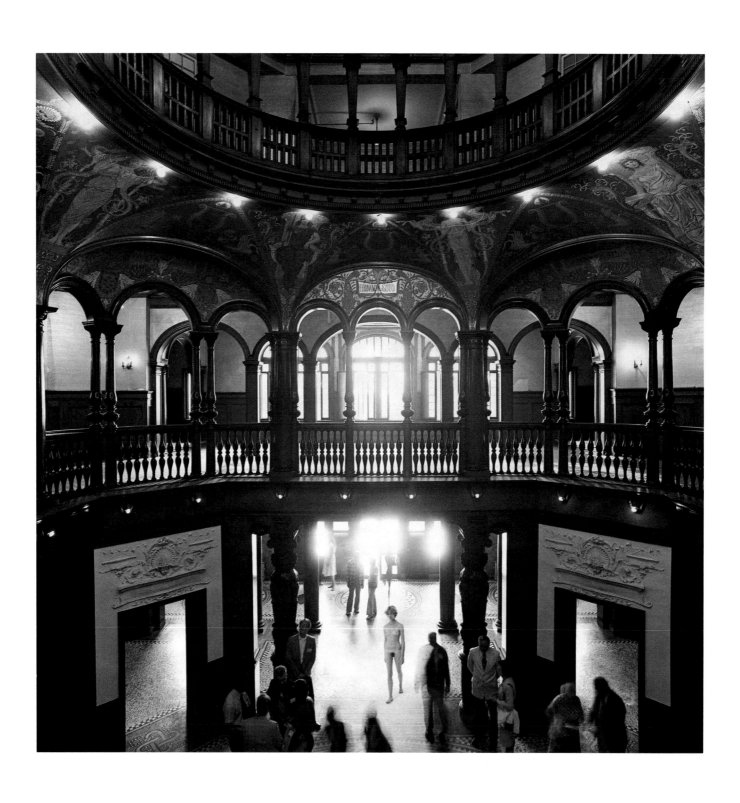

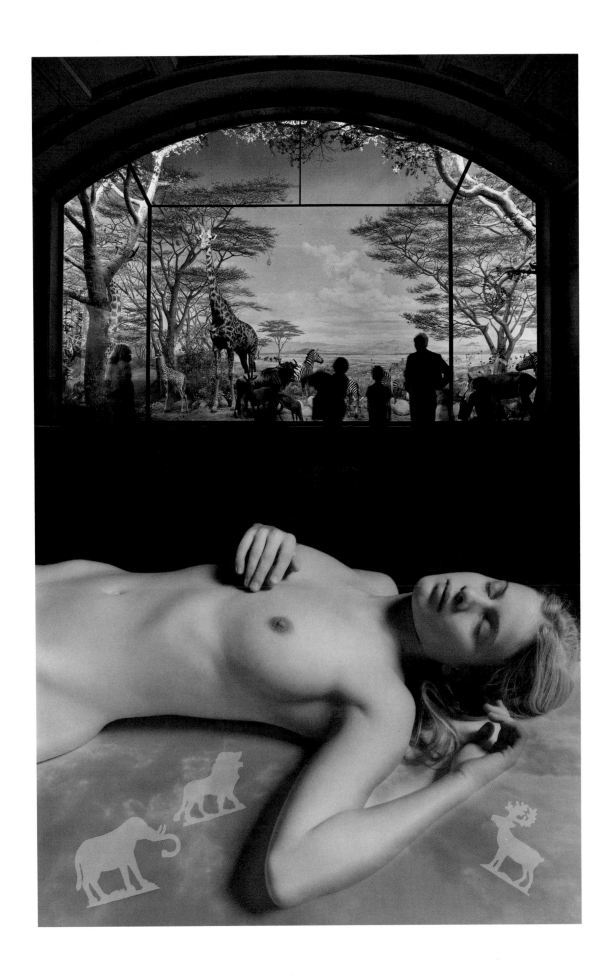

89 * *Animal Dream* 1 9 7 8

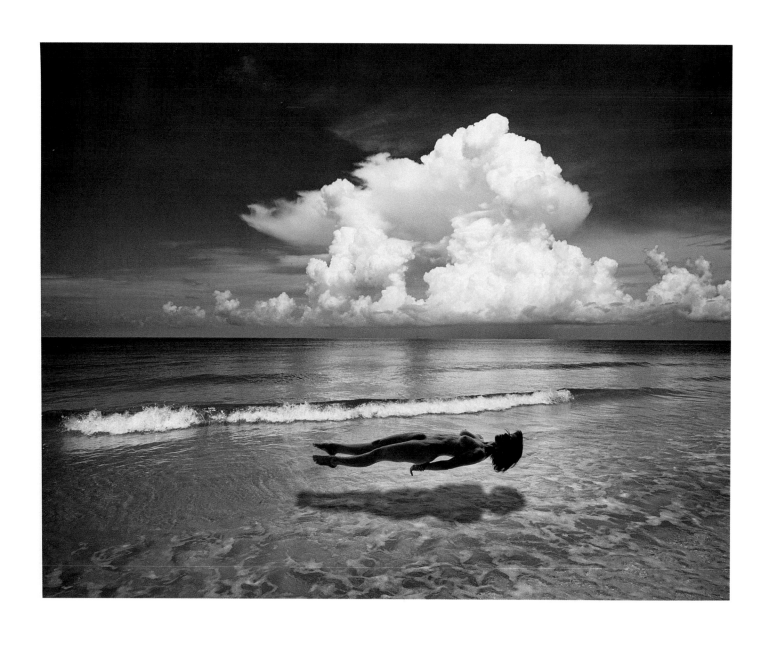

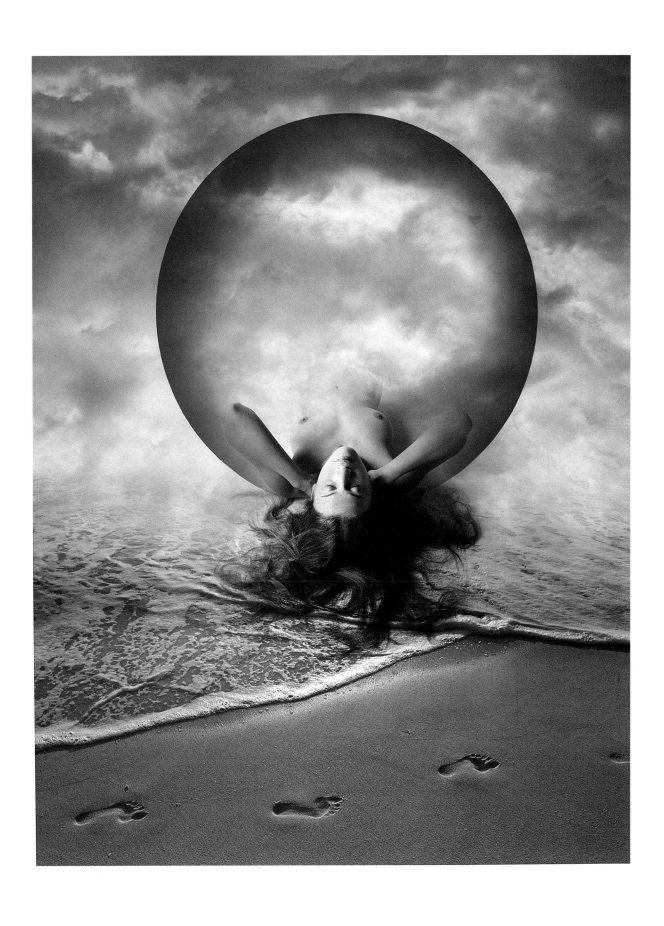

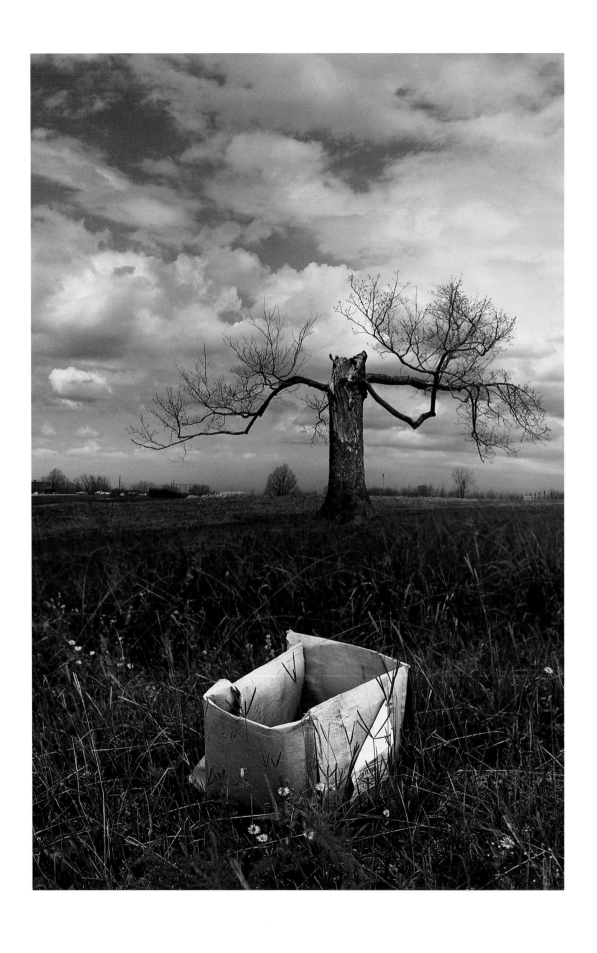

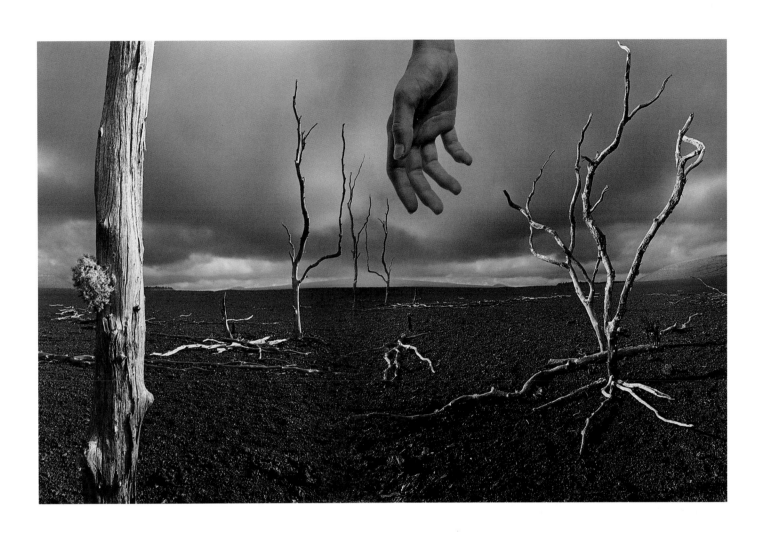

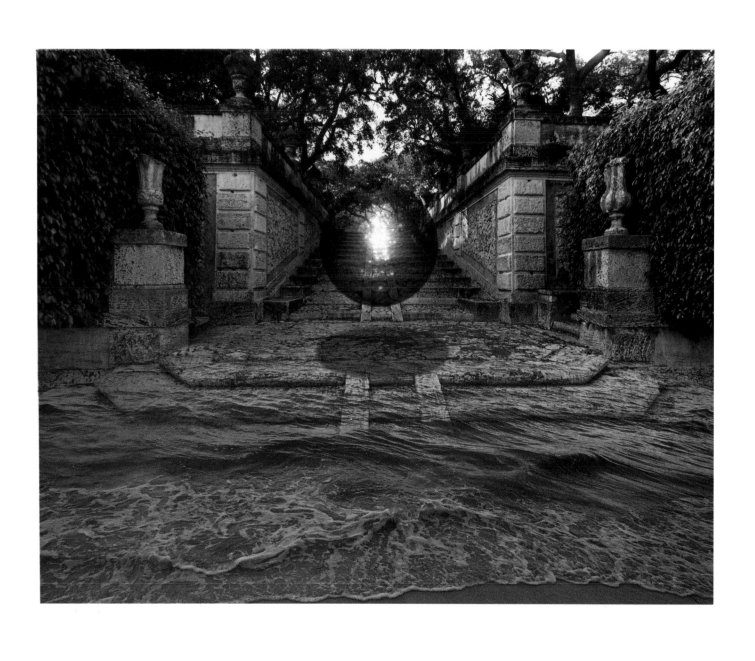

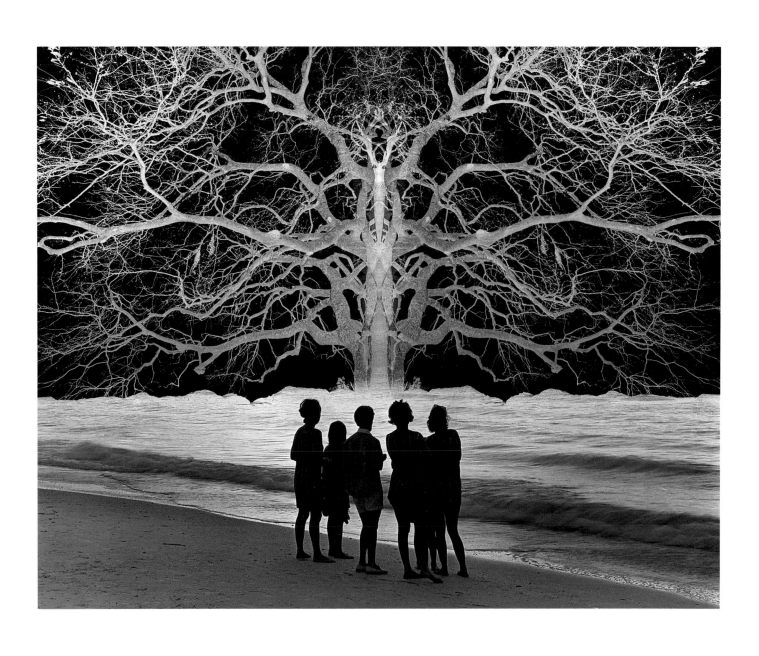

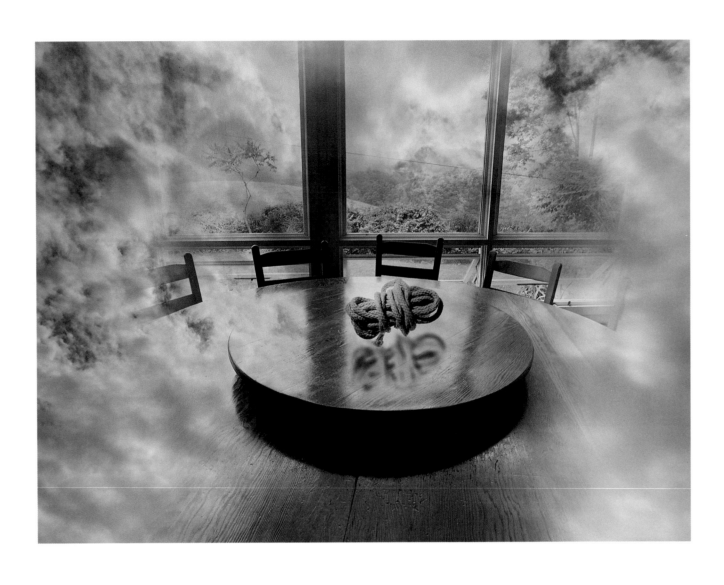

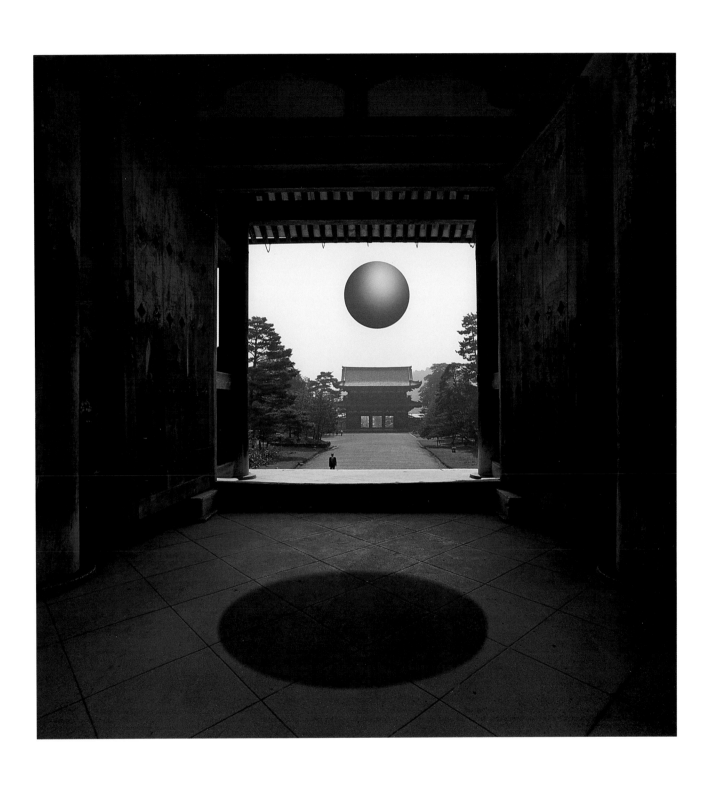

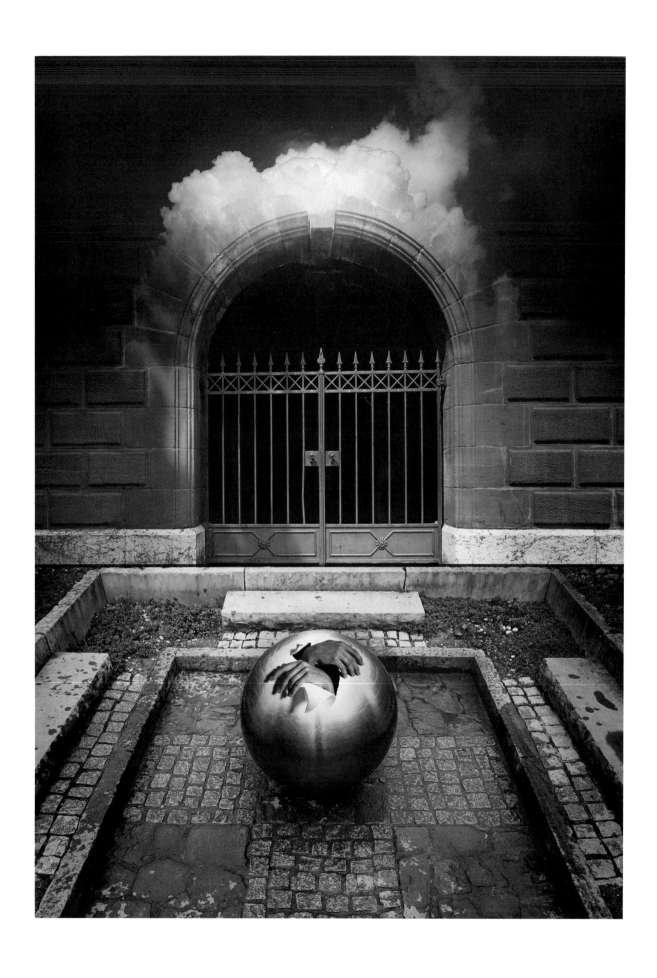

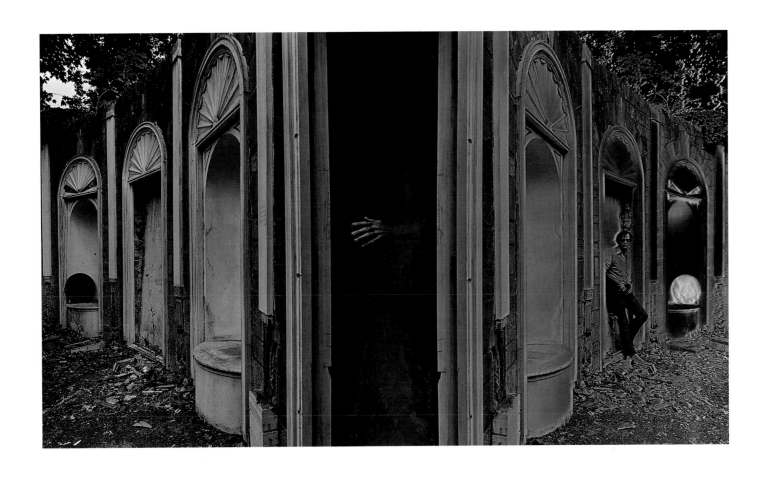

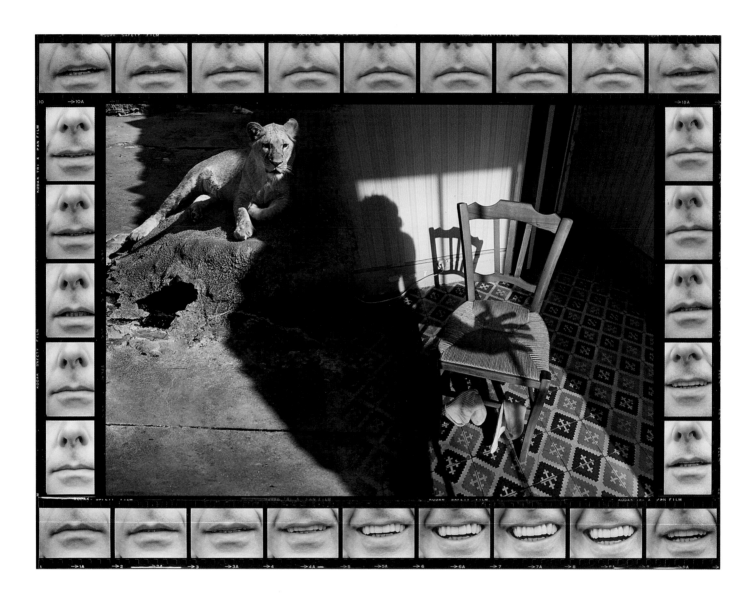

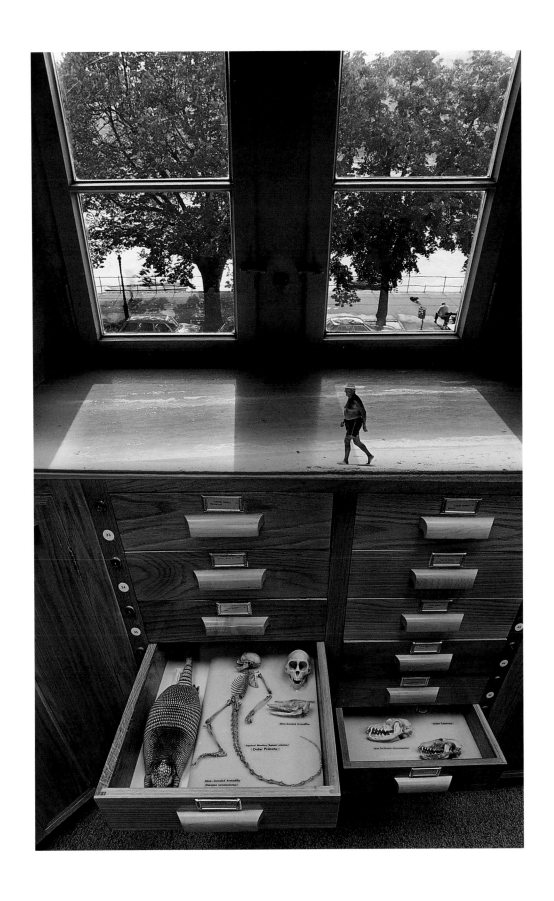

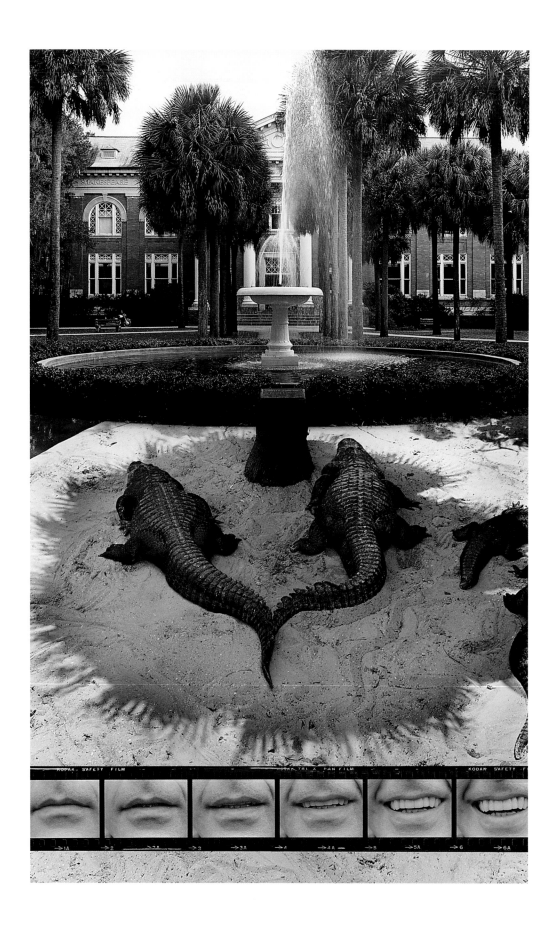

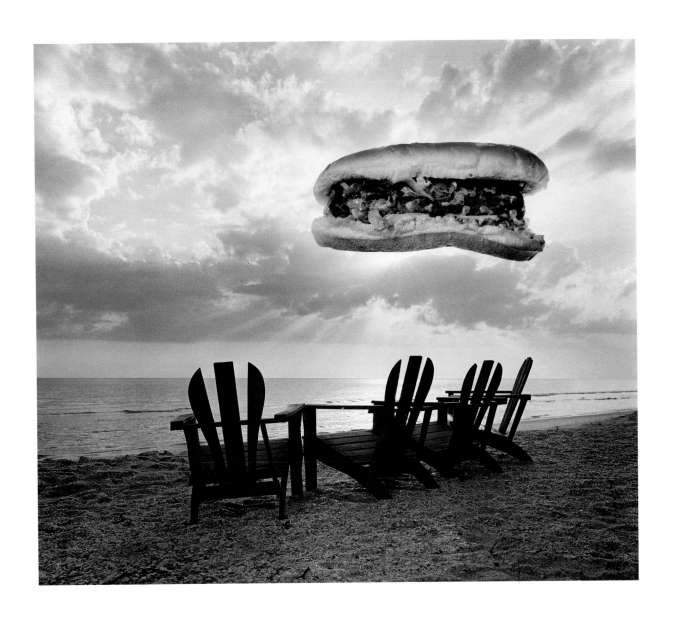

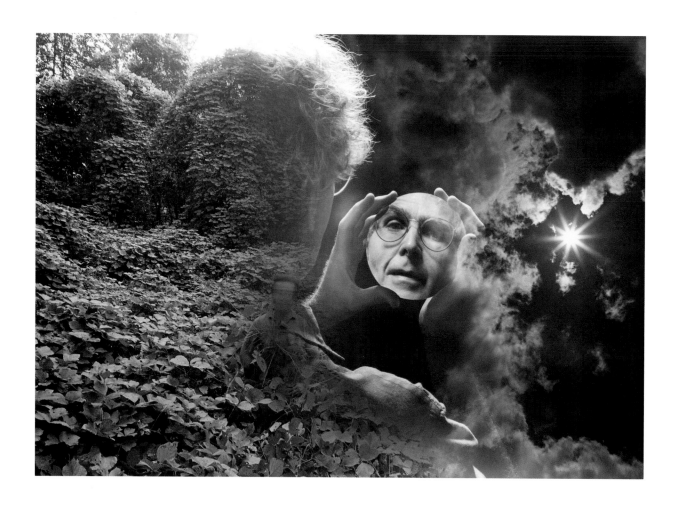

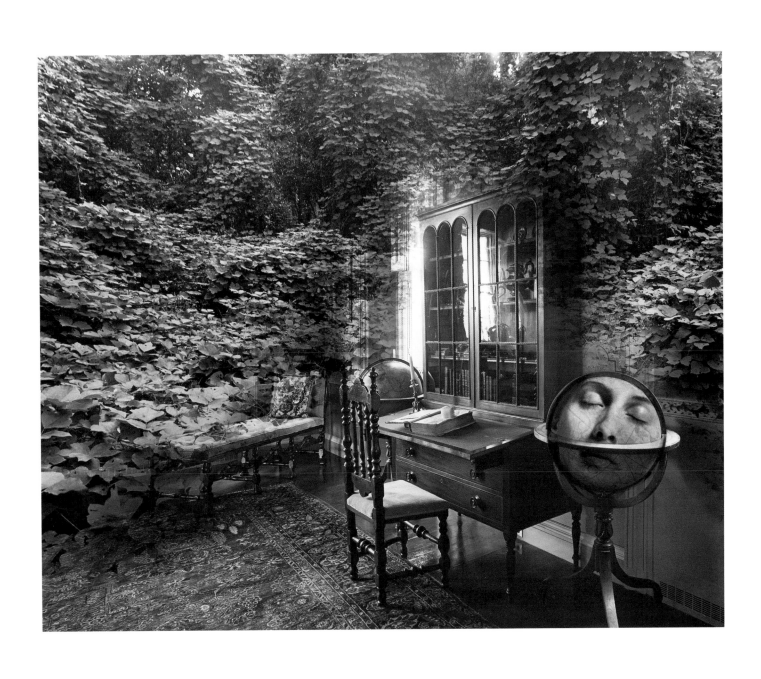

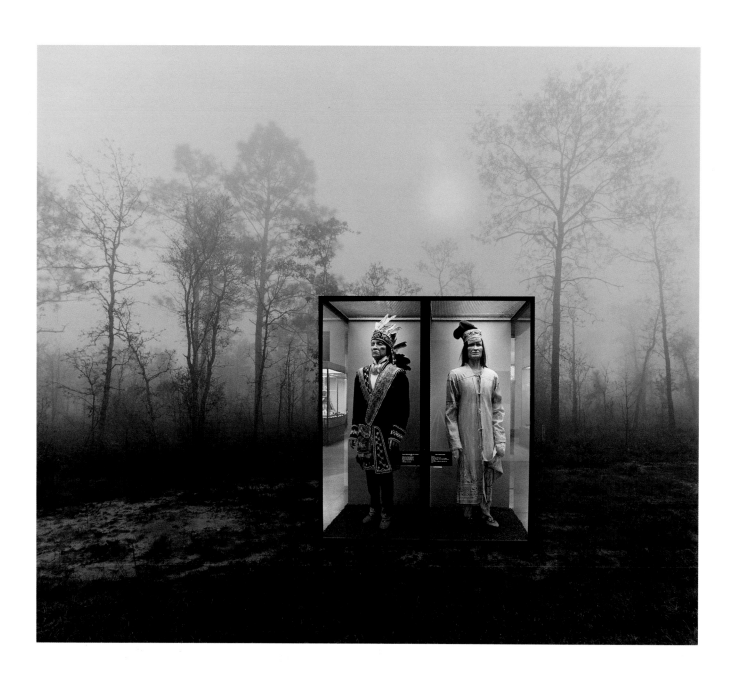

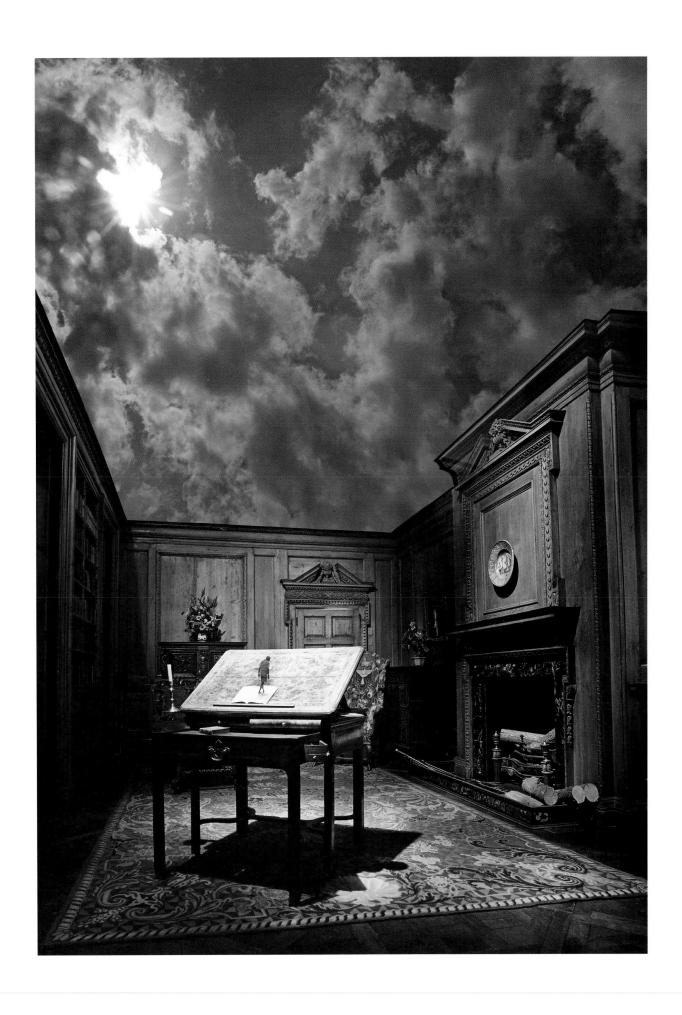

107 ✳ 1976

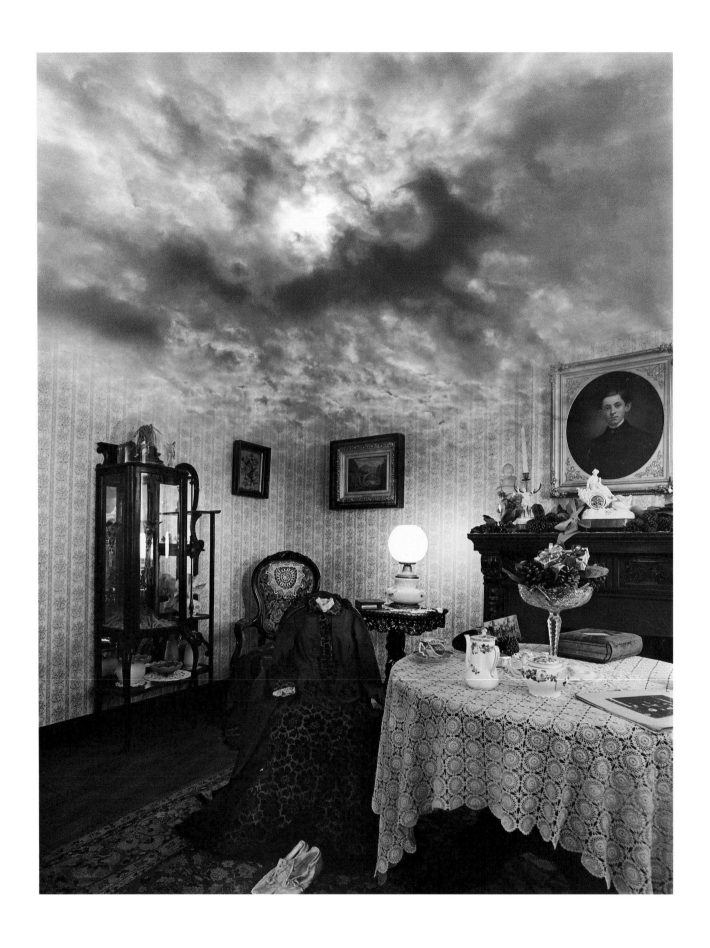

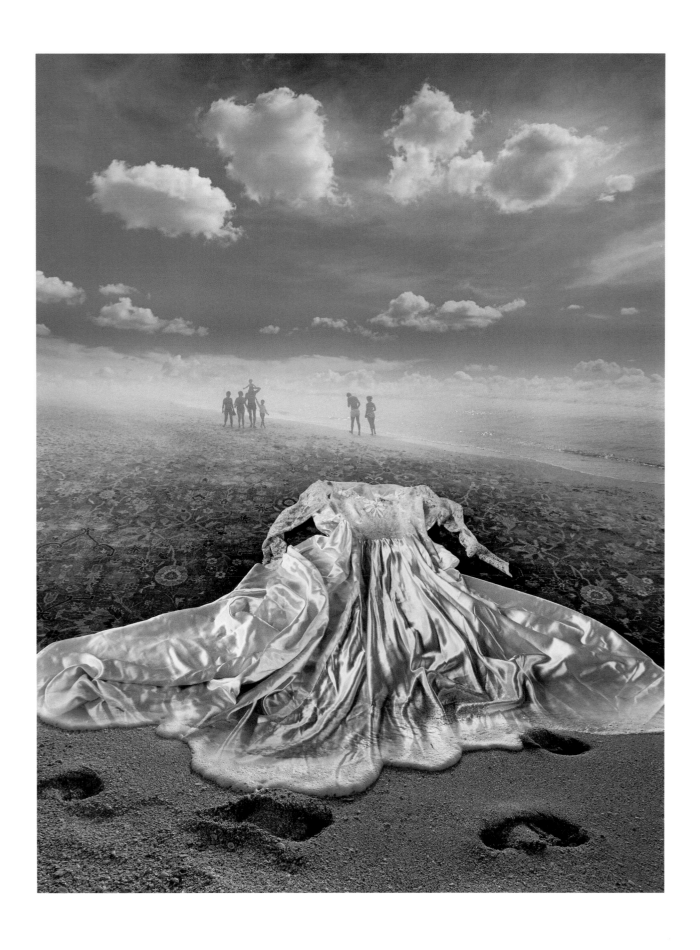

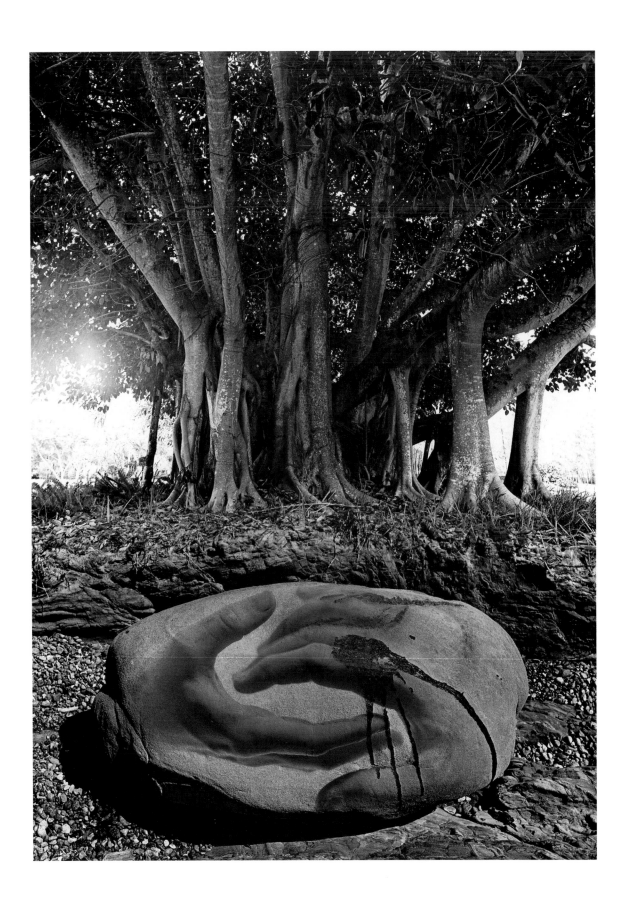

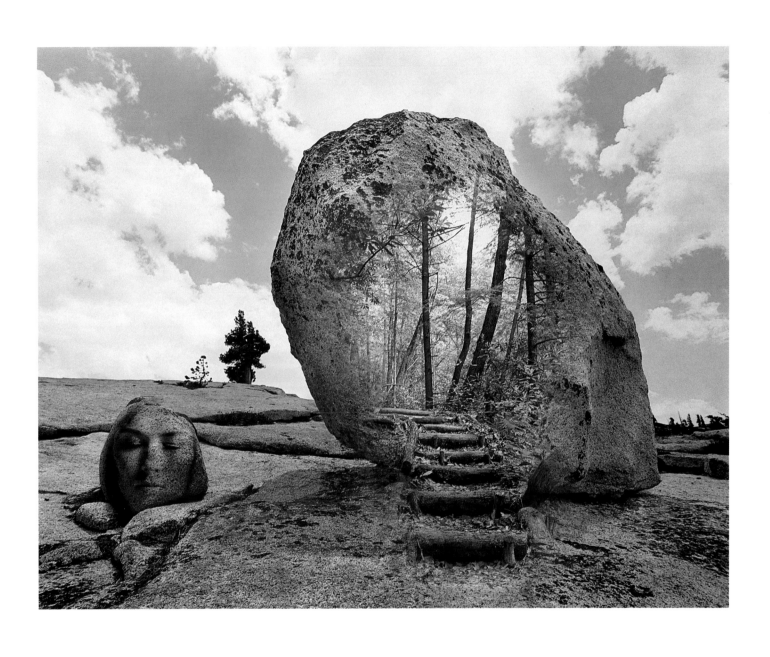

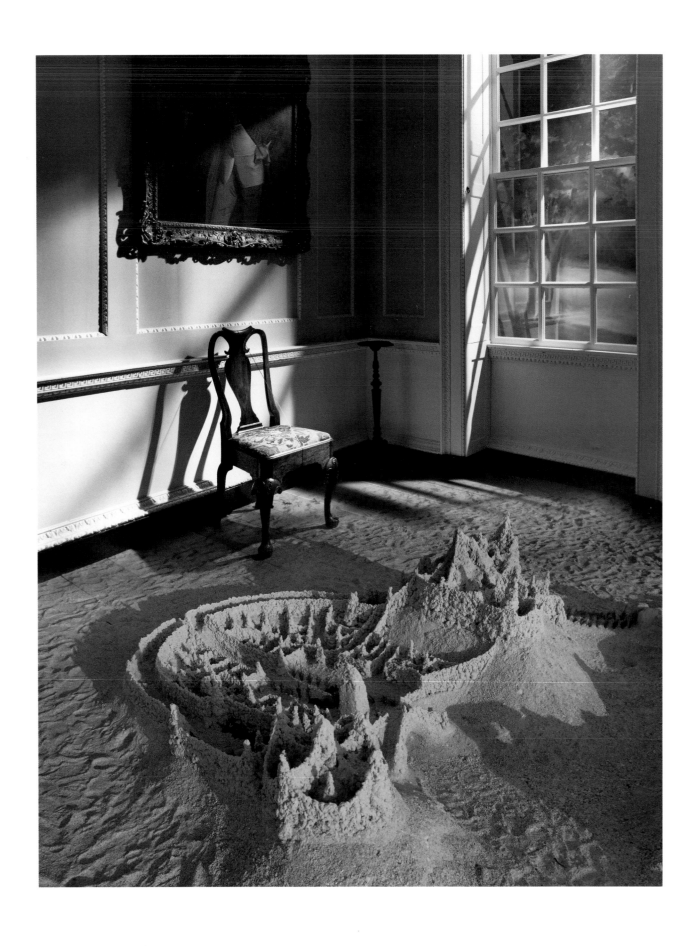